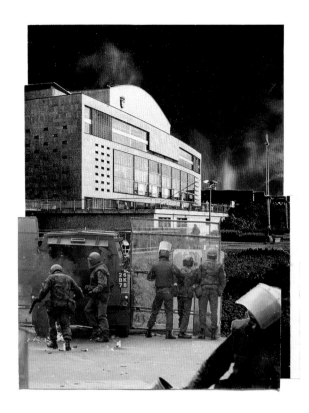

ART FROM
CONTEMPORARY
CONFLICT

SARA BEVAN

The author would like to thank the artists and their galleries for their
generous support in the production of this book. I would also like
to thank my colleagues Madeleine James, Kam Rehal, Caitlin Flynn,
Kathleen Palmer, Richard Slocombe, Jenny Wood, Ulrike Smalley, and
Angela Weight for their input, advice and knowledge. Special thanks
to Joe Bradbury for his support throughout.

For more information about IWM's art collection visit iwm.org.uk

Published by IWM, Lambeth Road, London SE1 6HZ
iwm.org.uk

ISBN 978-1-904897-743

A catalogue record for this book is available from the British Library.
Printed in Italy by Printer Trento.

All images © IWM unless otherwise stated.

Every effort has been made to contact all copyright holders.
The publishers will be glad to make good in future editions any error
or omissions brought to their attention.

Introduction

The works selected for this book were created across the last thirty-five years. While this is perhaps not the place to address the complex question of what constitutes contemporary art, the works chosen – although vastly different in some ways – are linked by thematic threads evolving across the period.

Art produced over thirty years ago may not initially appear to be particularly contemporary. In many ways the social context in which it was produced – the time of Margaret Thatcher and war in the Falklands, the Troubles stubbornly dragging on in Northern Ireland and the Cold War barely showing the smallest sign of a thaw – could seem like another time. However much of this work demonstrates an engagement with social, political and theoretical issues which continue to be pressing and relevant today: the roles of the media and of technology in war, national identity, the long-term impact of events, the fetishisation of weaponry and violence, the ubiquitous themes of loss and death and, finally, the role of the artist in responding to these issues. These themes weave throughout IWM's contemporary art collection. Artists' approaches and the media they choose to use have changed and fluctuated, while some of these themes have become increasingly urgent and amplified as both conflict and art have changed. Other pressing ideas, especially around technology, have emerged in parallel. New approaches to making images of conflict and traumatic places have evolved, and new technologies in both war and art have raised myriad new questions. However that period in the early 1980s appears to mark a shift in attitude which continues to resonate today.

IWM has been collecting and commissioning contemporary art since the museum's foundation in 1917. However the position, ambitions and approaches of the artists and their work were, of course, very different at that time. Historically, artists were employed to record wars by monarchs, religious leaders and governments; the resulting works were, more often than not, shaped by the commissioner. Today our general understanding of conflict is increasingly shaped by the media and the internet, with

their apparent promise of immediate access to events. In some ways even photojournalism is being overshadowed by the 'citizen journalist', camera phone in hand, and it is assumed, because of their inherent sense of immediacy, that these images present a version of 'the truth'. In these circumstances what can the artist contribute to our understanding of war and conflict?

The Falklands War, due to its geographical location and a British government that took advantage of this isolation, saw renewed press restrictions. Since then conventional access to the 'battlefield' has been limited in various ways, with today's journalists frequently embedded in closely-controlled situations. The media is often described as one of today's weapons of battle; many artists aim to stand outside of this. Working away from the limitations and pressures of journalism, artists can propose ideas, urging the viewer to think more deeply about what war is, about its immediate impact and its long-term repercussions. Some confront the media and its role in conflict directly, exposing over-simplified, constructed narratives. Others produce work that rejects the mainstream media's desire for spectacle, revealing long-term consequences and overlooked complexity. Artists can highlight the discrepancies between personal experience and a dominant narrative, proposing a more nuanced story. Art is also used as a means to communicate a personal or political commentary, or to mount a protest. It can propose or impose alternative viewpoints and encourage debate, prompting us to consider the ways in which we think about events, and the ways in which those events are presented to us.

Most of the works in IWM's contemporary collection have been acquired as purchases or gifts, but some of our most high-profile works are those that IWM has commissioned — works like Steve McQueen's *Queen and Country* and Langlands & Bell or Paul Seawright's work on Afghanistan. The nature of our commissions has changed a great deal since the current programme was launched in 1972. It initially built on the tradition of the war artist commissions of the First and Second World Wars, starting with Ken Howard's record of the British Army's activity in Northern Ireland. This was followed by a range of projects at home and abroad, by artists such as Patrick Procktor travelling to Belize, Humphrey Ocean working aboard HMS *Broadsword*, and Boyd and Evans looking at the role of women in the RAF. At first artists were tasked with creating work of a broadly figurative or documentary nature, but

in the last twenty-five years there has been a shift towards a personal or conceptual response to conflict. This approach has increasingly attracted high-profile artists and the work produced has become more probing, challenging and thought-provoking. The projects are commissioned by the Art Commissions Committee (ACC), which consists of both IWM curators and external curatorial and artist advisors. The ACC's sphere of reference now includes the commissioning of artworks relating to all wars in which there is involvement by British and Commonwealth forces, including as part of United Nations humanitarian or civilian operations. Recent topics have included Iraq and Afghanistan, but also Northern Ireland following the Good Friday Agreement and a site-specific soundwork by Susan Philipsz for IWM Duxford, responding to the history of that site and sonically recalling the wait for the safe return of aircraft during the Second World War.

IWM-commissioned artists are not always embedded within the military; some have worked with non-governmental organisations (NGOs), and increasingly artists are beginning to work independently. This is often an aspect of a commission which is dictated by the nature of the conflict. As warfare itself evolves, so too does the structure of the way in which the artists work. Increasingly the label of 'war artist' has become problematic. Occasionally the term has led to difficulties when the conflict to which an artist is responding is not recognised as a war by those involved. More importantly, IWM's later commissions are very different to the government-instigated projects of the First and Second World Wars which were unconventional and ambitious for the period, however their role was ostensibly one of propaganda. Some artists find the title of 'war artist' helpful in terms of responding to a tradition or gaining access to their subject matter, however on the whole the name is perceived as having connotations of a traditional, establishment-sanctioned viewpoint, very different to the innovative and often challenging actuality.

The shift towards more conceptual commissioning was prefigured by a change of approach towards the museum's art collection that took place at the beginning of the 1980s. This is largely, if not wholly, due to the vision and ambition of Angela Weight, who was appointed as Keeper of Art in 1982. Despite the conservative reputation of the museum at the time, she collected work by several of the period's most innovative and important artists. Weight also developed a progressive Artist in Residence scheme, launched

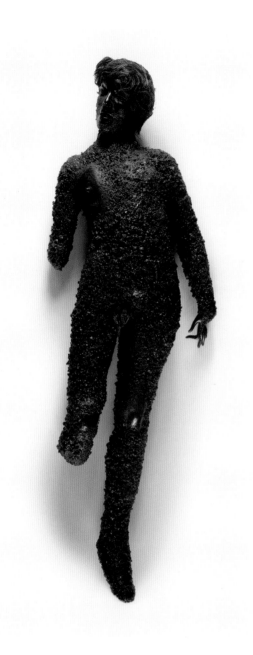

in 1984 with an installation by Denis Masi called *Shrine,* which aimed to explore ritual and myth as props of power. She also retrospectively acquired a number of important earlier works, including Colin Self's 1966 drawing *Guard Dog on a Missile Base* and *Nuclear Victim (Beach Girl)* of the same year, the latter, shown left, being one of the most horrific and challenging sculptures on the subject of nuclear holocaust. Using a charred shop model and a variety of other materials, Self explicitly confronts us with the horror of injuries sustained through nuclear attack. Another significant group of works acquired in the early 1980s was Clive Barker's sculpture from the 1960s and 1970s of skulls, gas masks, tanks and grenades. The most chilling of these works is *German Head 1942* (1974), shown opposite, which echoes the tradition of a military bust, but the figure is clad in a gas mask and cast in polished brass. The elongated neck adds to the surreal, alien-like appearance of the bust: haunting, fetishised, compelling and terrifying at once. Much of this work chronologically sets the scene for a contemporary collection which includes an ambitious range of probing responses to conflicts which have involved Britain since the 1980s – from the Falklands, the Cold War and the Troubles, to recent conflicts in Iraq and Afghanistan.

Reflection on earlier conflicts provides inspiration for another rich strand of the contemporary collection. One aspect of this is work by artists who have experienced traumatic events first-hand. Several,

Colin Self
The Nuclear Victim (Beach Girl)
1966
Mixed media, 280 x 1700 x 580 mm

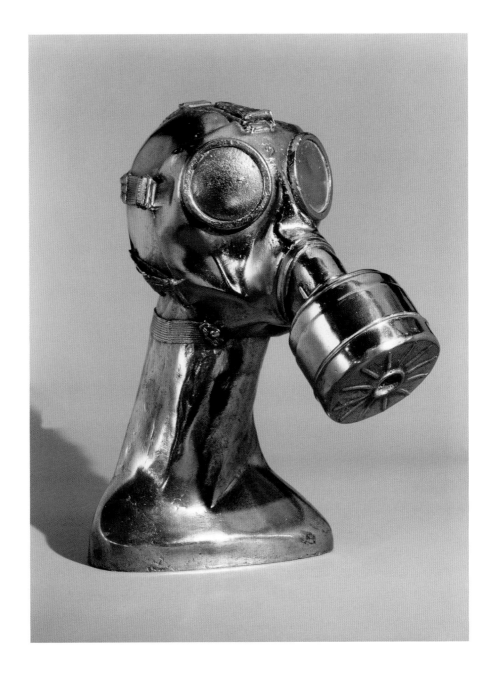

Clive Barker

German Head 1942
1974
Brass, 400 x 210 x 350 mm

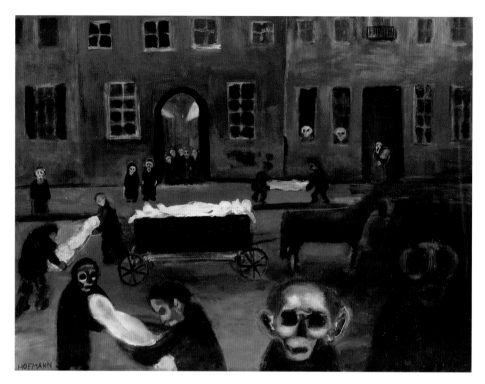

Edith Birkin
***The Death Cart
– Łódź Ghetto***
1980–82
Acrylic on board,
914 x 712 mm
Gift of the artist,
1983

including Shmuel Dresner, Roman Halter and Edith Birkin, were imprisoned in Nazi concentration camps during the Second World War. Birkin's haunting painting of skeletal figures and shrouded corpses in the Łódź Ghetto is shown here. For many of these artists it has been necessary for time to pass in order for them to begin to find a visual language with which to respond to the enormity of their experiences.

The other retrospective strand in the collection can be characterised as reflecting on the on-going repercussions of past conflict in today's world, a meditation on the nature of memory and the resonances of sites of terrible or traumatic events. Many artists explore visual methods of representing abstract concepts like memorialisation or loss. They also investigate how the way in which we remember conflict influences our view of the present. This is seen in works such as Chris Harrison's evocation of fading collective memory in his images of First World War memorials, Ori Gersht's hypnotic and poignant tale of a dancer surviving Auschwitz, and Willie Doherty's reflections on the very raw, recent and contested legacy of the Troubles.

For obvious reasons, the main emphasis in IWM's recent collecting has been on Afghanistan and Iraq. Works acquired include Mark Neville's *Bolan Market*, which captures an acute sense of the complex encounter between the local population and the International Security Assistance Force (ISAF) in a market place in Helmand Province; and kennardphillipps' *Photo Op*: an iconic, humorous and shocking montage of Tony Blair taking a selfie in front of a terrible explosion – a searing protest against the war in Iraq. Post-conflict Northern Ireland and the ongoing conflict in Israel/Palestine are also significant collecting themes, with recent acquisitions of Larissa Sansour's *Nation Estate* and work by Taysir Batniji and Emily Jacir. Many of these works explore ideas around land, borders, territory and identity, themes that are highly pertinent within this region, but also bleed throughout other conflicts.

Looking to the future, many of the subjects around which IWM collects will become less easily defined and categorised. Events have always been part of an interconnected web, but today, as Langlands & Bell show in their work *www.af*, the global, financial, physical, virtual and legal networks that link us mean that we are forced to question or expand our definitions of war and conflict. Shifts in how wars are fought and developments in technology and weapons have changed the way in which we perceive things. Wars do not always happen between nations. It is often said that we now live in a permanent state of emergency; from the Cold War to the War on Terror, the nature of warfare has changed dramatically and this has had a significant impact on the way that it is visually represented. Weapons like drones can be controlled over thousands of miles and terrorism can be home-grown: war is no longer confined to geographical boundaries or physical sites. Often it has no clear beginning and end. As a result, in the future, in collecting and staging exhibitions we must consider a whole host of elements including, but not limited to, the moral and legal issues around conflict and security, surveillance, asymmetric warfare, cyber warfare, radicalism and sectarianism. An important characteristic of contemporary art is that while promoting discussion, it is able to probe and unpick these often abstract concepts, in the context of their all too concrete and terrible consequences.

Sara Bevan
Curator, Contemporary Art
IWM

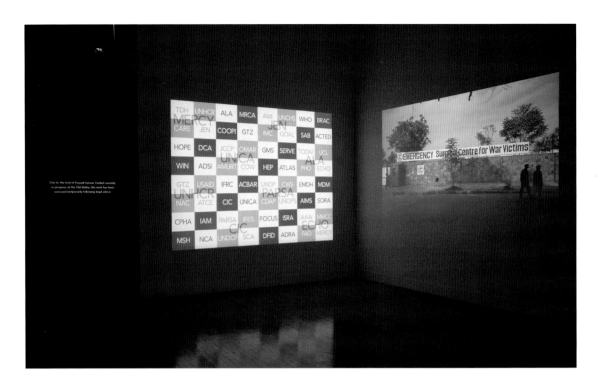

Langlands & Bell

NGO (installation view)
2003
Dual screen projection, infinite loop
Commissioned by the Trustees of the Imperial War Museum

Zardad's Dog (still)
2003
Video, colour, sound, 12 minutes
Commissioned by the Trustees of the Imperial War Museum

world wide web.af: The Boneyard
2004
Pigment print on paper, 660 x 850 mm

In 2002, Langlands & Bell were commissioned by IWM to respond to the aftermath of the September 11 attacks and the War in Afghanistan. Having travelled to Afghanistan, the work that they initially produced was a trilogy of films called

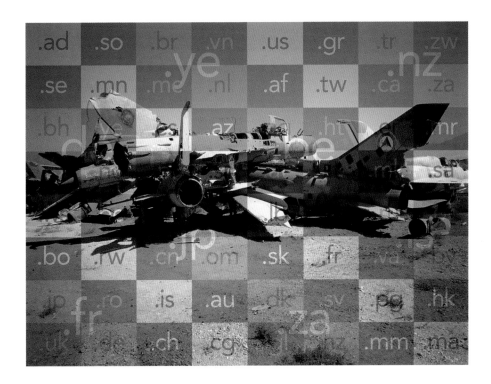

The House of Osama bin Laden. From the trilogy two films became part of IWM's collection: *Zardad's Dog* and *NGO*. Later a print portfolio, *world wide web.af*, was also acquired.

Zardad's Dog shows the trial, in the Supreme Court in Kabul, of Abdullah Shah, nicknamed 'Zardad's Dog'. It was alleged that Shah was kept as a 'human dog' by Faryadi Sarwar Zardad, an Afghan warlord, and used to attack victims with his teeth before murdering them. At the time the artists described the participants in the court case as symbolic of the people of Afghanistan rebuilding their country. However the trial proved controversial when Shah was found guilty and later executed in secret, making this the first capital trial after the fall of the Taliban, and causing an outcry amongst human rights campaigners.

Following their visit to Afghanistan Langlands & Bell talked of their surprise at the number of non-governmental organisations (NGOs) operating in the area, and this led to their film *NGO* and the later print portfolio *world wide web.af*. The film is a slideshow of signage for international and local NGOs based in Afghanistan, juxtaposed with graphics of their acronyms, emphasising the multiplicity of organisations at work in the war zone. The print portfolio takes this a step further, comprising photographs taken by the artists of war debris and ruined buildings. Superimposed over the photographs are grids containing acronyms for not only NGOs, but also for security services, terrorist and banned organisations, aviation codes and the top-level domain names of countries involved in the war. The artists' previous practice has often explored global systems of circulation and exchange. Here they highlight the physical, virtual and economic networks present in the war zone.

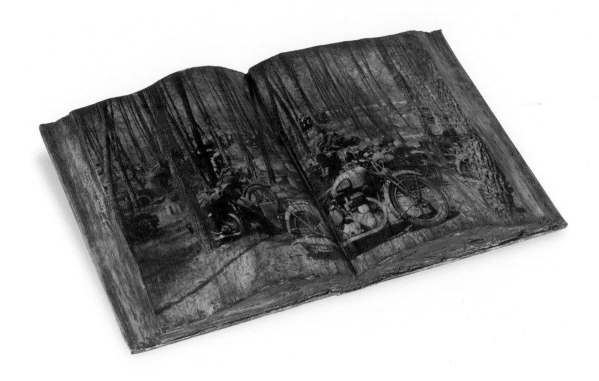

Hughie O'Donoghue

A Monument in Rouen
2003

Oil and inkjet on gampi tissue and a prepared book,
360 x 580 x 50 mm

Gifted by Dasha Shenkman through the Contemporary Art
Society, 2013

This is one of a series of haunting book works of
the same title, which the artist produced shortly
after he had inherited and read his father's journals
and letters. O'Donoghue's father had seen active
service during the Second World War and had
written frequently to his mother during this period.
A Monument in Rouen represents moments in
the artist's father's experiences as a motorcycle
reconnaissance rider, serving as part of the
retreating British Expeditionary Force in France
in 1940. It comprises a photograph from IWM's
archives, subtly painted and layered onto
an open book, which highlights the narrative
nature of the work. O'Donoghue makes us aware
of the reconstructed nature of these memories,
exploring both personal and historical narratives.
As the image emerges through the rich layers
of paint and glaze, he also highlights the acts
of remembering and forgetting.

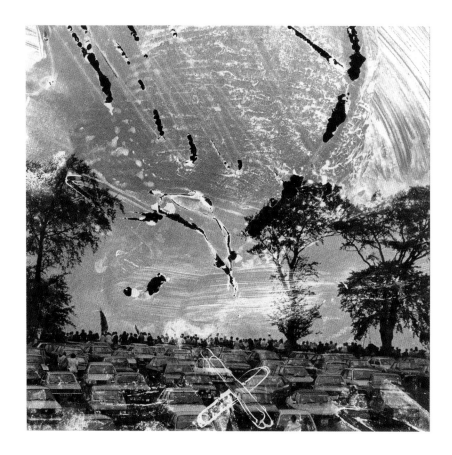

Victor Sloan

***Entering the Field* (from the series *Drumming*)**
1986
Silver gelatin print with toner and gouache,
580 x 580 mm

Produced before the changes heralded by the
Good Friday Agreement, Victor Sloan's images
of the Orange Parades (the Unionist marches
that take place annually across Northern Ireland
around 12 July) are some of his best-known works.
They also typify his unusual technique of reworking
and scratching his negatives. This technique
has resulted in some of Sloan's most violent and
distressed images, amplifying the impression of
an atmosphere of electrical tension surrounding
the marches. Here we see 'the field', the arena
in which speeches are made at the end of the
marches. The title of the work suggests the
beginning of a ritual, however the artist raises
questions regarding its purpose. In his sepia-
tinted, corroded image the march is not simply
an emblem of cultural pride, but an anachronism,
repeated in an attempt to assert identity and
territorial ownership.

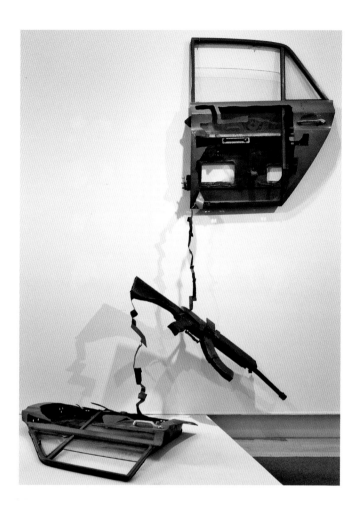

Bill Woodrow

Two Blue Car Doors
1981
Car doors, enamel paint, 1030 x 930 x 120 mm

In Bill Woodrow's sculptures from this period something extraordinary happens in the space between two objects. Material is scooped out of everyday items and melded into something new, often creating surreal and sometimes humorous juxtapositions. This sense of the strange may be the viewer's initial experience of *Two Blue Car Doors*, which is one of two sculptures by Woodrow in IWM's collection. However there is something here that is more acutely telling than with many of the artist's more poetic or lyrical works. Here we see ribbons of metal running between two car doors, fusing to form an AK-47 assault rifle. Within its 1980s context the sculpture suggests drive-by shootings, and perhaps more specifically the sectarian executions of the Troubles in Northern Ireland. *Two Blue Car Doors* continues to resonate strongly today; the vehicle has become a weapon, packed with explosives, a lethal car bomb.

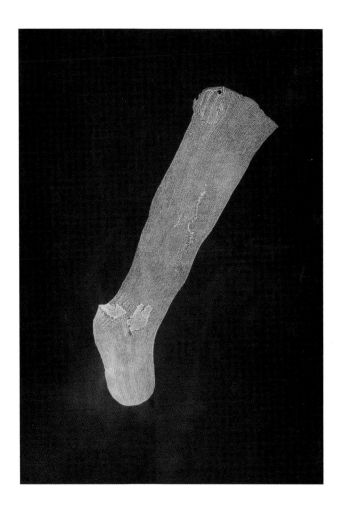

Annabel Dover

Cyanotype (RAF sock)
2010
Cyanotype, 1123 x 775 mm
Gift of the artist, 2011

Dover explores the power attributed to objects as markers of memory, and the social relationships that objects can represent. This image, or to be more accurate, after-image, of an RAF sock is one of a series of cyanotypes that she produced from her family's Second World War keepsakes and lucky charms. The distinctive blue colour comes from the method used in production, in which an object is placed on treated paper and exposed to the sun. When the object is removed a white shadow remains, leaving only the object's 'aura', its mystical powers. The items Dover uses belie the dramatic stories that they represent. This woollen sock was worn by Dover's stepfather when he was shot down and injured over Germany whilst serving with the RAF. As a result of his injuries he lost his leg, but the German nurses who cared for him washed and carefully mended the sock. It became, for him, symbolic of their compassion.

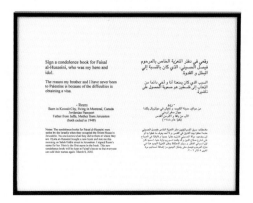

Emily Jacir

Reem (from the series *Where We Come From*)
2001

Mixed media, 227 x 330 mm and 222 x 285 mm

Presented by the Art Fund and the Esmée Fairbairn Foundation to IWM and Wolverhampton Art Gallery

'If I could do anything for you, anywhere in Palestine, what would it be?' This question is the starting point for Emily Jacir's series *Where We Come From*; she asks it of other Palestinians living in exile, both abroad and within Palestine. Jacir offers to use the freedom of movement afforded by her US passport to fulfil these wishes, and to then document the action. *Reem* is one of two such actions represented in IWM's collection, and embodies the contradictions of Palestinian identity – the reality that many Palestinians live as part of a diaspora, often prevented from returning to the country in which they were born. The work investigates the idea of dislocation and restriction of movement, this example being particularly poignant as the artist has not been able to fulfil the respondent's wish to sign a condolence book for Faisal al-Husseini, a Palestinian human rights activist and politician. On the text panel Jacir records that the original condolence books were at al-Husseini's former headquarters in East Jerusalem when it was raided by the Israelis. She therefore fulfils the request by establishing a new book of condolence, shown in the photograph.

Mark Neville

Bolan Market (still)
2011
Single channel projection, 6 minutes
Commissioned by firstsite Colchester and
16 Air Assault Brigade, in association with IWM

Mark Neville spent the winter of 2010–2011 in
Helmand Province, Afghanistan, at the invitation of
16 Air Assault Brigade. While there he made a series
of photographs and several films addressing the
complex relationship between the local population
and the International Security Assistance Force
(ISAF). _Bolan Market_ shows a market in Lashkar Gah,
newly-liberated from Taliban control and enjoying
a renewal of commerce. Neville filmed it from
a British armoured Husky vehicle during a single
pass through the market. He makes skilful use of
slow motion to create soundless, timeless scenes,
intentionally avoiding the conventions of media
reporting. The technique gives a fluid grace to the
subject, revealing details we would otherwise miss;
every telling nuance of the local population's mixed
responses to the patrol vehicle is captured in their
faces and body language.

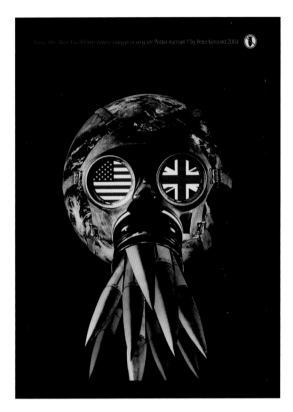

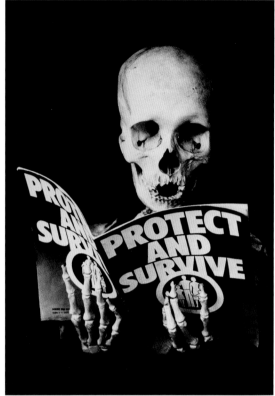

Peter Kennard

Stop the War Coalition Poster Number 1
2003
Lithograph on paper, 593 x 418 mm

Protect and Survive
1984
Silver gelatin print, 605 x 428 mm

Cruising on London (from *Target London*)
1985
Lithograph on paper, 297 x 420 mm

Photomontage has been a key medium for Peter Kennard from an early point in his career, his adoption of the medium coinciding with the increasing influence of politics on his work. During the 1980s, Kennard produced several iconic anti-nuclear montages, in particular for the CND (Campaign for Nuclear Disarmament) campaign against the stationing of American cruise missiles in Britain. In 1983 he was commissioned by the Greater London Council to produce *Target London*, a series of eighteen posters satirising the Conservative government's *Protect and Survive* pamphlets, which gave the public advice on what to do in a nuclear attack. Kennard's cover showed a skeleton reading the

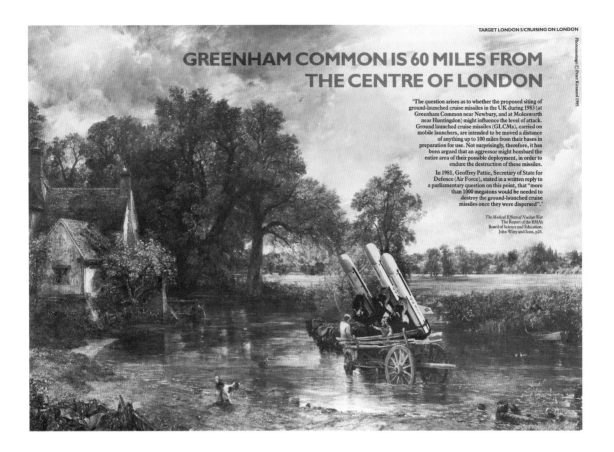

GREENHAM COMMON IS 60 MILES FROM THE CENTRE OF LONDON

'The question arises as to whether the proposed siting of ground-launched cruise missiles in the UK during 1983 (at Greenham Common near Newbury, and at Molesworth near Huntingdon) might influence the level of attack. Ground launched cruise missiles (GLCMs), carried on mobile launchers, are intended to be moved a distance of anything up to 100 miles from their bases in preparation for use. Not surprisingly, therefore, it has been argued that an aggressor might bombard the entire area of their possible deployment, in order to endure the destruction of these missiles.

In 1981, Geoffrey Pattie, Secretary of State for Defence (Air Force), stated in a written reply to a parliamentary question on this point, that "more than 1000 megatons would be needed to destroy the ground-launched cruise missiles once they were dispersed".'

The Medical Effects of Nuclear War
The Report of the BMA's
Board of Science and Education.
John Wiley and Sons, p24.

Photomontage © Peter Kennard 1985

official booklet. Many of these bleak images re-appropriated his earlier iconography, such as *Haywain*, featuring Constable's hay cart overloaded with cruise missiles. The re-use of imagery is something Kennard has done throughout his career, partly, he says, because of the cycle of history repeating. For example his 2003 poster for the Stop the War Coalition uses one of his most recognisable motifs, a globe wearing a gas mask bursting with missiles. An early, 1980s Cold War version of the image shows US and Soviet flags in the eyes of the mask, while the updated version (pictured here) uses American and British flags, in protest against the 2003 Iraq War. The move towards war in Iraq led to Kennard's partnership with Cat Phillipps, under the banner of kennardphillipps. The two worked together to produce images and installations which fiercely opposed that war (see page 50). For Kennard, getting his work into the world is extremely important and, as with his collaborations within kennardphillipps, his images have always been disseminated via numerous contexts and formats. He encourages the public to share his images via social media. One of his recent works is an artist's book, *@earth*, which visually explores interwoven issues around war in the Middle East, capitalism and the environment, demonstrating an on-going engagement and call for action in relation to the politics of today.

Chris Harrison

Sheerness, Kent (from *Sites of Memory*)
1995
Cibachrome print, 762 x 1524 mm
Gift of the artist, 2000

This image is from a series of photographs of First World War memorials that Harrison took for his 1997 IWM exhibition, *Sites of Memory*. The unsentimental images explore the relationship between these shared markers of collective or personal memory and their surroundings. Frequently the images highlight the incongruity of the juxtaposition between past and present, the monuments surrounded by more recent buildings, overgrown greenery and street furniture, emphasising the passage of time. Often the banality of the surroundings sits uncomfortably with the gravity of the events memorialised, suggesting the fading of collective memory and a dwindling recognition of these previously resonant structures.

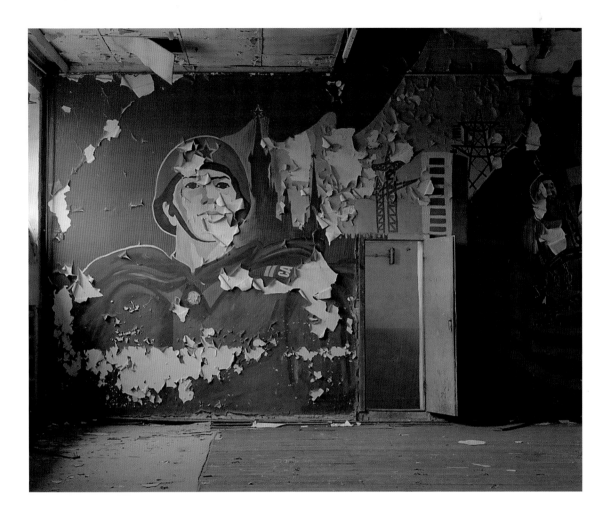

Angus Boulton

Cinema Mural, Krampnitz. 16.3.99
1999
C type print, 405 x 508 mm

Between 1998 and 2006 Angus Boulton took a series of photographs at Soviet military bases in and around Berlin. Abandoned when Soviet forces left East Germany, many were soon to be demolished. One series of images was a survey of the gymnasia on these sites. Other images, like this one, captured the peeling layers of propaganda, official murals, insignia and instructional diagrams in the dilapidated buildings before they disappeared completely. While the photographs have a strong formal quality, emphasising the almost archaeological approach taken by the artist, they also convey a strong sense of absence and the texture of decay. The sites stand not only as witnesses to the activities of their former inhabitants, but also as a manifestation of a belief system, its downfall and disappearing legacy.

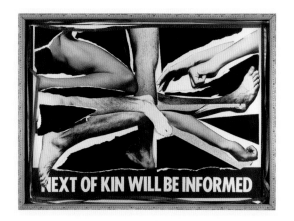 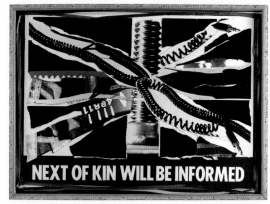

Michael Peel

Rejoice, Rejoice
1983
Mixed media, 800 x 1105 mm (each)

Rejoice, Rejoice takes its title from Margaret Thatcher's statement to the media on hearing that the island of South Georgia had been recaptured during the Falklands War. The imagery used in this diptych is in sharp contrast to its celebratory title, emphasised by the sinister phrase 'next of kin will be informed'. The arrangement of disembodied limbs in the first part of the work questions the human cost of warfare. The second part shows a configuration of cables and photographic film, highlighting the interrelationship between communications, war and the media, an association which was becoming increasingly evident during that period. The work references the geometry of the Union Jack and, draped in red white and blue ribbon, it questions what is done and what is lost in the name of nationalism and heroism.

This work is a precursor to Peel's *Modern World* series, also in IWM's collection, which later developed many of these ideas in the context of more recent conflicts.

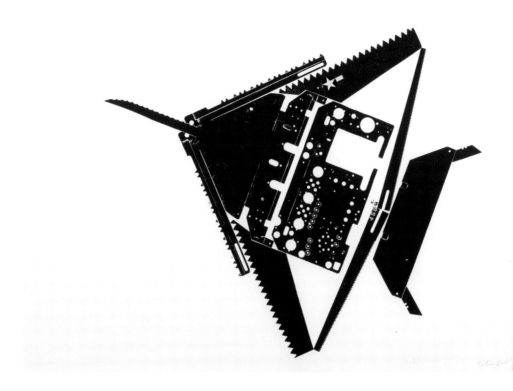

Colin Self

Stealth Bomber I; The Odyssey/Iliad Suite (The Siege of Troy)
2000

Etching from found wood and metal objects,
748 x 1063 mm

Colin Self's work has dealt with a huge range of social and political issues throughout his career, however his work on the nuclear threat during the 1960s and 70s is amongst the best-known. Self cites the Cuban Missile Crisis in 1962 as a profound influence. It made him acutely aware of the fragility of Cold War relations and the consequent threat of nuclear oblivion. Shortly after this time, the sight of American strategic bombers taking-off and landing at airbases in his native Norfolk led him to produce several extraordinary print series of stylised nuclear bombers. They were made using an arrangement of found metal objects which the artist used as etching plates, giving the impression of a simple mechanical object, but with an overriding sense of menace. IWM has one of these early prints in its collection. In this more recent work, Self returned to the subject of the bomber in his autobiographically-themed exploration of war, *The Odyssey/Iliad Suite*. In this series the bomber is updated with new stealth technology. It maintains the sense of foreboding present in the original work through a tactile exploration of the fetishisation of weaponry and mechanical warfare.

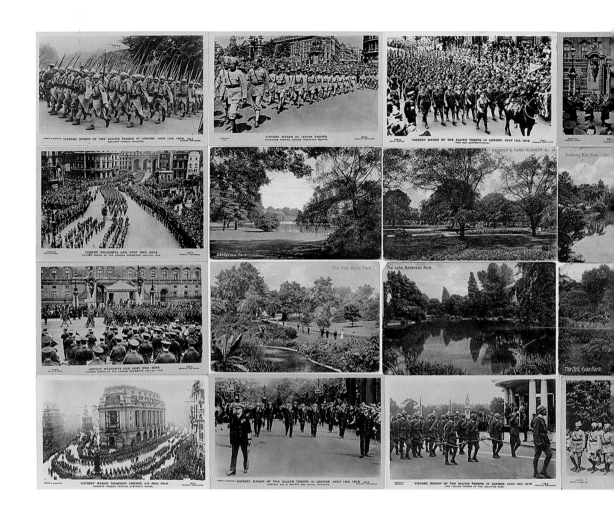

Gilbert and George

Victory March
1980
Postcard sculpture, 660 x 1280 mm

Gilbert and George have created art together since they met at St Martin's School of Art during the late 1960s. During that time they began to create art that rejected prevalent approaches to sculpture, famously presenting themselves as Living Sculpture. In 1972 they began composing Postcard Sculptures which consisted of arrangements of postcards, mainly from the early twentieth century, purchased by the artists from professional dealers. The artists described these works as 'mentalscapes', the cards carefully chosen and arranged to evoke a mood. *Victory March* is one of a pair of postcard sculptures in IWM's collection, and shows an arrangement of First World War military marches surrounding a central grid of idyllic pastoral and park scenes. Gilbert and George have often explored symbols in their art and here they clearly juxtapose military victory and bombast with idealised, peaceful British landscapes, in a questioning of national identity and nationalism.

Tuesday 3rd April 1973

'Late last night a 28 year old man disappeared from a pub.
It wasn't until this morning that his body was found abandoned in
a quiet park on the coast.'

Paul Seawright

Sectarian Murder: Tuesday 3rd April 1973
1988

C type print, 785 x 610 mm

Purchased with the assistance of the Art Fund

This is one image from Paul Seawright's *Sectarian Murder* series, an early work in which he photographed the sites of sectarian attacks that took place in and around Belfast during his childhood. Each image is accompanied by text from contemporary newspaper reports describing the facts around the murder, but with the victim's religion removed. Through these pairings Seawright highlights the way in which sites can gain meaning and significance. The incongruity of a children's seaside park and the terrible details included in the text is shocking, but the work goes beyond this immediate impact to evoke a more general sense of threat, not specific to this conflict. *Sectarian Murder*, alongside work by other artists of the period, heralded a new approach to representing conflict through its aftermath. Seawright and others intentionally questioned and avoided the simplistic language of the media, and used photography to draw attention to overlooked complexity and the repercussions of events. This was an approach that Seawright developed further almost fifteen years later when he was commissioned by IWM to make work in response to the War in Afghanistan (see page 31).

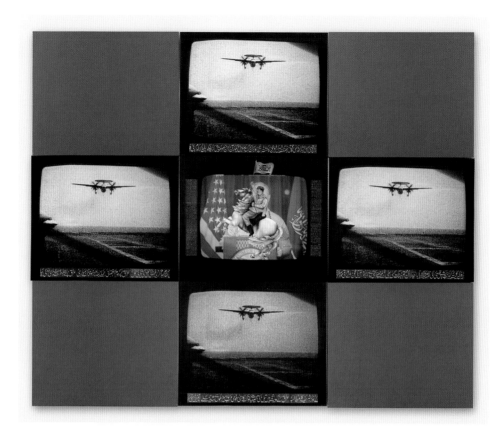

Rasheed Araeen

White Stallion
1991
Mixed media, 1625 x 1990 mm

London-based Araeen was visiting Pakistan during the Gulf War in 1991 and watched the early stages of the war unfold on the news channel CNN. Saddam Hussein enjoyed wide support in Pakistan at the time, and a particular poster of Hussein riding a white horse sold widely there. Araeen superimposes this image of Hussein over a photograph of a television screen showing General Schwarzkopf, the US Commander-in-Chief, giving a press conference. Hussein appears to be signalling defiance, but the planes in the surrounding images visually counteract this.

This image of Hussein refers to layered Islamic and Western historical sources. It makes a visual reference to Jaques-Louis David's painting *Napoleon at the Great St Bernard Pass*, while in turn the David painting makes reference to Hannibal crossing the Alps. Through these layers and his use of Arabic and Urdu text, the artist makes an intentionally contradictory work. By highlighting the cross-cultural origins of our points of reference, he reveals cultural associations and national allegiances or divisions as being anything but clear-cut.

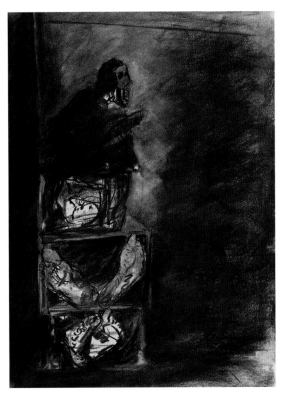

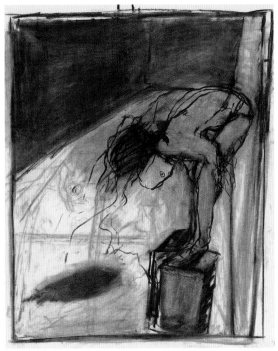

Albert Adams

Iraq: Abu Ghraib
2006
Charcoal on paper, 595 x 420 mm
Gift of Edward Glennon

Iraq: Abu Ghraib
2006
Charcoal on paper, 595 x 420 mm
Gift of Edward Glennon

Albert Adams' drawings are a response to the photographs and news reports of the abuse of prisoners at Abu Ghraib prison in Iraq in 2004. In the media these images became shorthand for the atrocity, but Adams avoids clichéd repetition of the images and instead explores wider themes of incarceration and violence, expressing a stark condemnation of human cruelty. Born in racially-segregated South Africa, Adams moved to Britain in 1953. Influenced by the raw and bleak work of artists such as Francis Bacon, throughout his career he explored the ideas of injustice and both personal and political conflict. These drawings come from a wider series of monochrome works in which he makes reference to the Holocaust and to the genocide in Darfur. One of the works shown here shows an ape-like figure sitting on a stack of coffins. This figure often occurs in Adams' work to represent mankind's base, brutal instincts, and highlights the metaphorical side of his work.

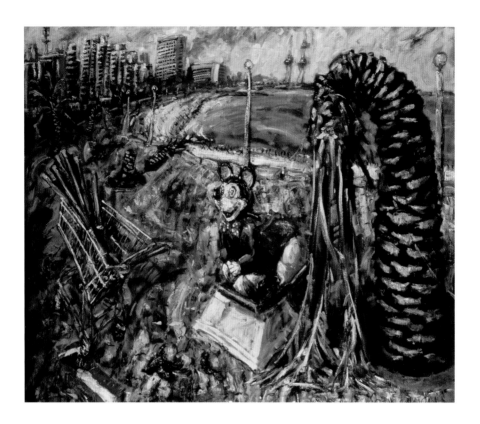

John Keane

Mickey Mouse at the Front
1991

Oil on canvas, 1730 x 1985 mm

Commissioned by the Trustees of the Imperial War Museum

John Keane was commissioned as IWM's official recorder in the Gulf in August 1990. He had previously produced work on several conflicts, including Northern Ireland and the Falklands. When he arrived in the Gulf, Keane found a war that was fought with remote weaponry and was seemingly broadcast instantaneously. Much of his resulting work reflects on the nature of the war and is a personal, political commentary on the situation, raising questions about the media, money and power.

Shortly after the liberation of Kuwait, Keane found himself in Kuwait City where he came across the scene depicted in the controversial *Mickey Mouse at the Front*: a children's park which had been used as a latrine by Iraqi soldiers. Shortly before the painting went on display the *Sun* newspaper printed an image of it, calling it 'depraved' and an insult to the sacrifice of British soldiers, claiming that it showed Mickey Mouse on the toilet. In fact, Keane had seen the Mickey Mouse rocker as a symbol of the US influence on Kuwait, and was struck by the surreal scene. The ensuing furore highlighted the discrepancy between the public expectation of the war artist's role, and the artist's compulsion to reflect on his own experience.

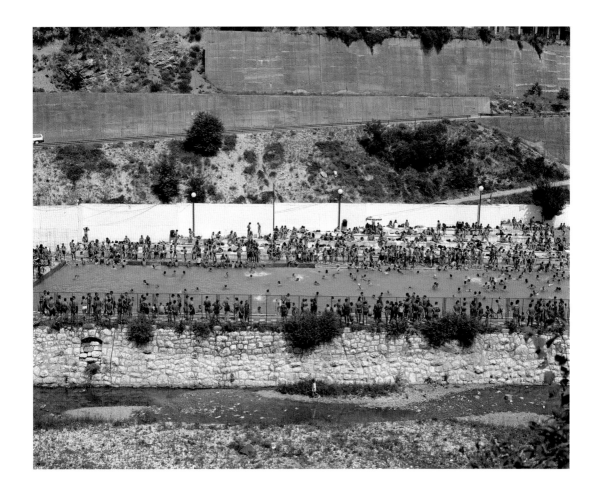

Ori Gersht

Vital Signs
1999
C type print, 1223 x 1533 mm

London-based Israeli artist Ori Gersht often explores the relationship between history, memory and landscape in his work. Part of a series called *Afterwars*, *Vital Signs* is a photograph of Sarajevo taken after the end of the war in Bosnia. The media interest in the conflict was enormous, but had dwindled by the point Gersht arrived. He hoped to explore the longer-term impact of the conflict on the city and the population. IWM has two other photographs from the *Afterwars* series. One shows a modernist building damaged by shellfire, the other shows a plastic wreath from a cemetery, which was just out of shot, near the swimming pool shown here. The series combines a feeling of optimism with the scars of war. There is mortar damage on the concrete wall above the pool, alluding to the far-reaching repercussions of conflict, but in contrast the overall feeling is one of rejuvenation, of signs of normal life returning to the city.

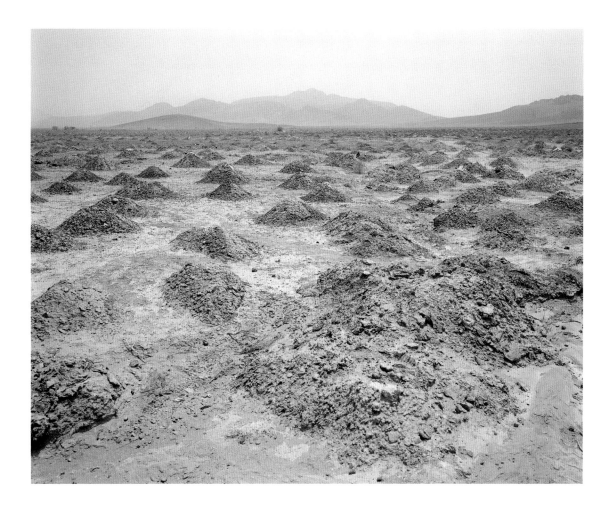

Paul Seawright

Mounds
2002
Cibachrome print, 1010 x 1265 mm
Commissioned by the Trustees of the Imperial War Museum

In 2002 IWM commissioned Paul Seawright to respond to the War in Afghanistan which had started the previous October. Building on his previous work, he was interested in how an artist might engage with conflict in a way that was different to the dramatic spectacles of photojournalism. The resulting photographs of minefields show a seemingly empty landscape, which in reality is both lethal and inaccessible. Seawright says that he had 'always been fascinated by the invisible, the unseen, the subject matter that doesn't easily present itself to the camera'. In contrast to the photojournalist's urge to capture a dramatic moment, Seawright's work attempts to photograph the invisible, to evoke a sense of the longer-term reverberations of war.

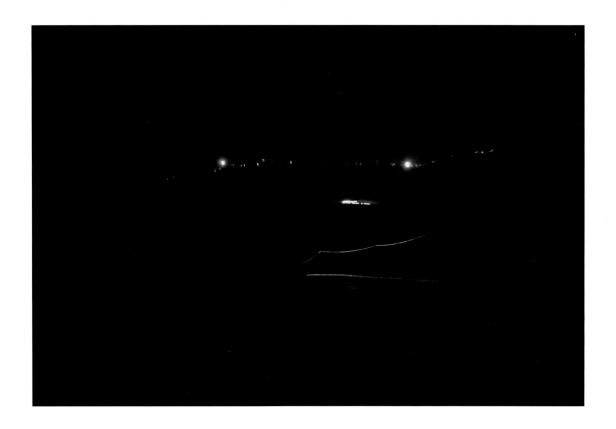

Yazan Khalili

Landscape of Darkness 6/f3.5
2010
C type print, 660 x 1000 mm
Presented by the Art Fund and the Esmée Fairbairn Foundation
to IWM and Wolverhampton Art Gallery

Yazan Khalili's *Landscape of Darkness* consists of
a series of photographs taken at night in area 'C',
the Israeli-controlled West Bank in the Palestinian
territories. These deceptively simple images were
taken during a series of night-time drives out
of Ramallah. The artist points out that as a result
of the long exposures required for nocturnal
photography, these images can be seen as portraits
of time. There is an added tension in this highly-
politicised landscape, where the Palestinian artist
was in fear of being found by an Israeli soldier as
he waited in the darkness for the shutter to click.

The darkness acts almost as a filter. Through
concealment of the terrain and boundaries, the
artist poses questions about power relations,
territory and resources. In some of the other images
from the series Israeli settlements are illuminated
by bright lights, but here only the green light of the
Mosque alerts us to the presence of Palestinian
towns and villages.

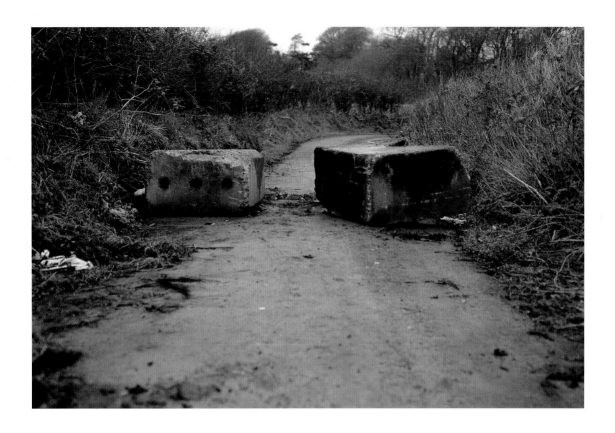

Willie Doherty

Unapproved Road
1995
Cibachrome print, 1255 x 1830 mm

Throughout his career Willie Doherty has explored the portrayal of his native Northern Ireland in the media and in broader visual culture. In doing this he also raises questions about the manipulative power of photography, and about identity. *Unapproved Road* is one of a number of images that Doherty took of the border roads of Donegal. It shows a makeshift roadblock, seemingly harmless at first glance. But once we know that this is a border road in rural Northern Ireland, we assume there is a darker significance. The photograph has a staged quality, calling into question our perception of the image. The position of the cement blocks suggests an impact, perhaps an indication of past violence? The blocks are also interventions in the landscape, blocking the route and reminding us of the significance of land and territory in the conflict in Northern Ireland. Doherty highlights the way in which images can be easily manipulated, their meanings changed through context and the viewer's own preconceptions.

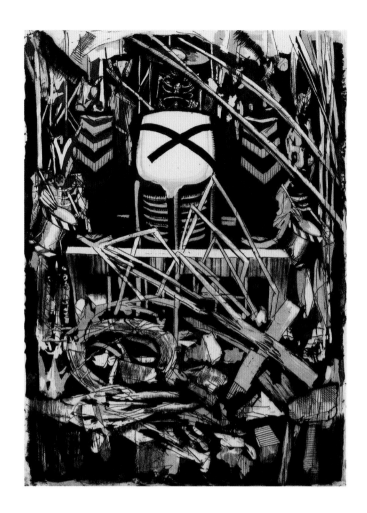

Michael Sandle

Untitled (from *Death and the Bulldozer*)
1985

Aquatint and etching on paper, 415 x 380 mm

Gift of the artist, 1985

Themes of death, war and destruction proliferate throughout Michael Sandle's sculptures, drawings and prints. Some of the artist's earlier works in IWM's collection adopt a sombre approach to these themes, suggesting relics of past conflict.

In this print series ominous figures, skeletons and haunting masked drummers march through the images. A skeletal Death, accompanied by this sinister procession, drives a bulldozer through a pile of war debris, suggesting the destructive onward march of time or history. The presence of the apocalyptic drummer suggests a criticism of 'heroic' war and the fanaticism of nationalism. This imagery is more than a simple *memento mori*, it is a cry against the fetishisation of weaponry and violence.

Peter Kalkhof

Stealth
1995
Acrylic and foil on canvas, 1460 x 1800 mm

This is an unusually figurative painting for Peter Kalkhof, whose practice was predominantly an abstract investigation of colour, geometry, space and philosophy. These elements weave through *Stealth*, a large painting based on an F-117 stealth bomber used during the Gulf War 1990–1991. Kalkhof was intrigued by the geometry and form of the aircraft, both compelling and menacing. He was also fascinated by the contradiction of man's creativity in inventing tools for destruction. The painting employs multiple textures and layers of paint combined with a scattering of collaged foil particles, to explore the formal and functional qualities of the plane. Kalkhof described the foil pieces as representing radar detection, referring to the low visibility of stealth aircraft. For him, these dual qualities of presence and absence were also a metaphor for painting and the attempt to represent physical space on a two-dimensional canvas.

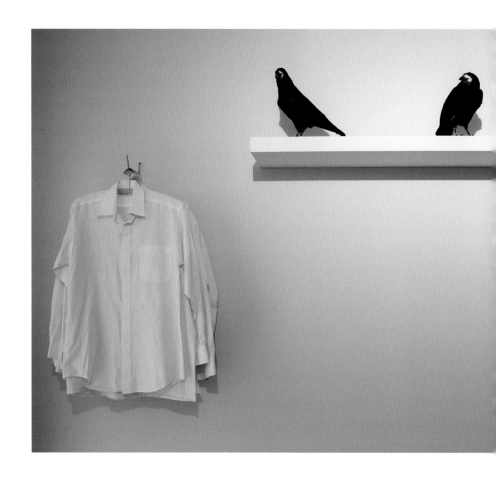

Graham Fagen

Theatre
1999
Mixed media installation, dimensions variable
Commissioned by the Trustees of the Imperial War Museum

In 1999 IWM commissioned Graham Fagen to undertake research in Kosovo following the recent conflict between the Serbs and Kosovan Albanians. Fagen's preparatory research for his visit included a study of Shakespeare's *Macbeth* and *Henry V*, Plato's *Republic* and Homer's *Iliad*, as well as contemporary histories of war in the Balkans. Having decided early on that his work would take the form of a play, Fagen used his time in Kosovo to gather content for the piece. His subject was to be relationships and communication, and how intransigence leads

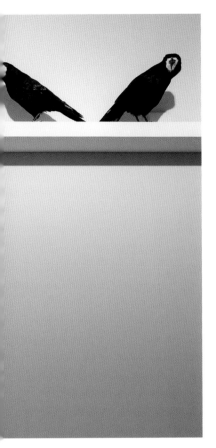

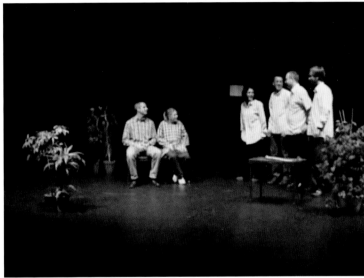

to violence. It was not until he went to Kosovo that the artist found the symbols, images and language that now constitute the complex scenario that confronts the visitor in *Theatre*.

The installation comprises various elements which are arranged around a central film: a play in which the deteriorating relationship between two warring groups is acted out. Each group is identified by their shirts, and the two sets of shirts are also shown within the installation. During the play photographs taken by Fagen in Kosovo flash up on screen. These combine aspects of contemporary daily life with symbols of Kosovo's complex history. Above the gallery a 'parliament of rooks' observes the developing tension, making reference to a significant fourteenth century battlefield, the Field of Blackbirds. It was here that in 1989 Serbian leader Slobodan Milošević gave an inflammatory speech which set the parameters for the subsequent deep divide between Kosovan Serbs and Albanian Kosovars.

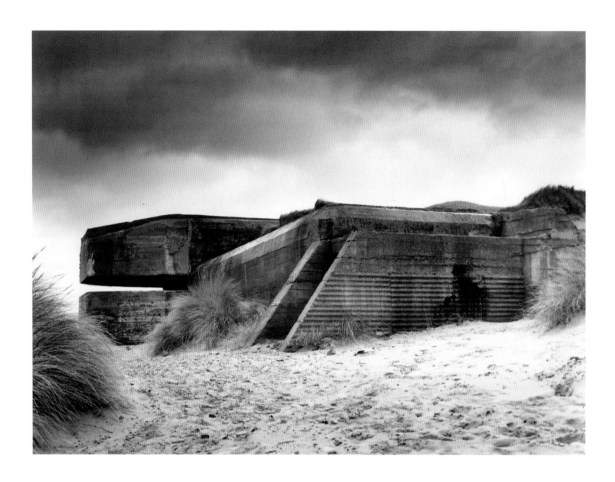

Peter Mackertich

Calais
1996
C type print, 1020 x 1290 mm

Calais is from Peter Mackertich's series of black and white photographs of the remains of the Atlantic Wall, the Nazi fortification built along the Atlantic coast of what was occupied Europe. The enormous hulk of reinforced concrete fills the frame, dominating and mute. Its nature as a statement of power is made explicit. Today, the structures are slowly disappearing, worn by the sea, covered in foliage or drifts of sand. Yet their presence is not melancholy, but haunting, a stubborn reminder of a grim and brutal past.

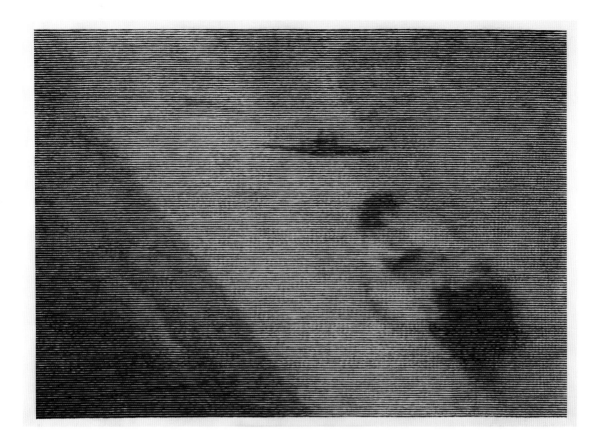

Christiane Baumgartner

Game Over
2011
Woodcut on paper, 1065 x 1400 x 1130 mm

Christiane Baumgartner's print combines the contemporary and the traditional. Using the age-old technique of woodcut, the German artist has transformed a still from a videoed documentary about the Second World War into a strangely contemporary image. The sequence of reproduction that has taken place – the original filming of the event, the use of this footage in a documentary, the subsequent artist's video and finally the woodcut – captures a sense of how conflict can seem distant and unreal when portrayed by the media. The title suggests the culmination of a computer game, another reference to simulation and unreality, further emphasising our sense of detachment.

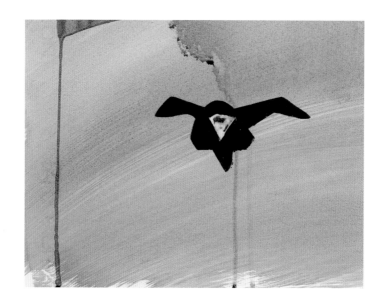

Alison Wilding

Drone 4
2012
Acrylic ink on paper, 197 x 257 mm

Widely regarded for her sculpture, Alison Wilding's drawings have become an increasingly significant part of her practice. Her visual language is predominantly abstract, but many of her recent drawings make reference to recognisable forms of aerial vehicles, stealth bombers, missiles and, in this case, drones. Here Wilding does not make an overt political statement about the unmanned aircraft, which have become synonymous with contemporary conflict. She portrays them as sinister bird-like silhouettes, suggesting creatures from a science fiction film rather than remotely-controlled machines.

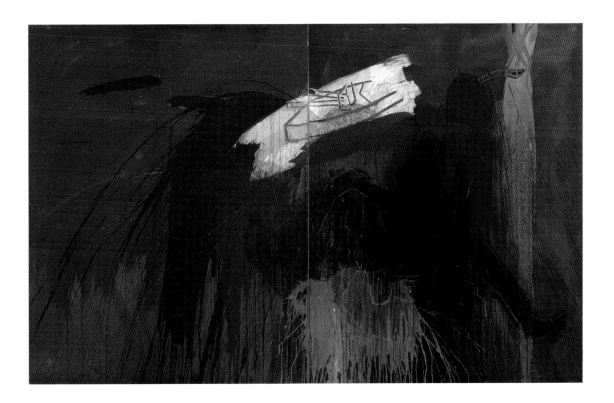

Bruce McLean

Broadside
1985
Acrylic on canvas, 2130 x 3340 mm
Gift of the artist and the Anthony d'Offay Gallery, 1990

Best known as a performance artist, Bruce McLean painted *Broadside* as a precursor to a performance. This explosive diptych was a response to the way in which the events of the Falklands War were represented in the British media. On a glowing red backdrop McLean references a dramatic photograph of HMS *Antelope*, an iconic image which was widely reproduced on television and in the newspapers of the day. The photograph showed one of a series of large explosions aboard the ship after a failed bomb disposal attempt. In McLean's painting the image comes to stand for the uncompromising jingoism in media coverage of war. The ship appears above a dark, flailing female figure, apparently caught in a tidal wave of paint emanating from the ship's side. This may refer to a secondary aspect of the painting which is also intended as an attack, a 'broadside', on the art world of the period, its egos and its overblown rhetoric.

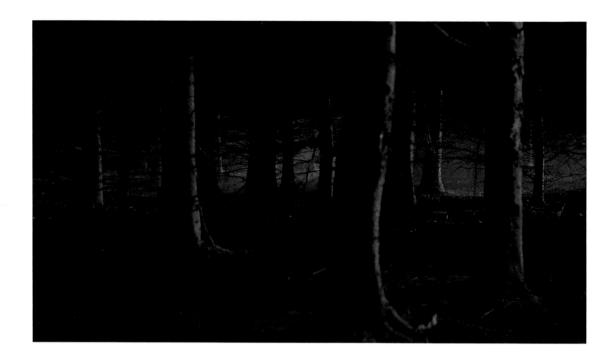

Willie Doherty

Buried (still)
2009
Single channel projection, 8 minutes
Purchased with the assistance of The Art Fund.
Purchased jointly with Wolverhampton Art Gallery

Buried is a film about landscape, memory and the difficulties of addressing the legacy of violence in a post-conflict situation. The artist questions the idea that following the Good Friday Agreement in Northern Ireland, past events would be easily forgotten. Here the landscape itself is oozing with repressed histories. The viewer is taken on a disturbing journey into a dark, claustrophobic pine forest. Insects crawl in the rotting wood on the forest floor and the trees themselves leak an unidentified substance. The sound in the forest becomes increasingly threatening: thunder or a suppressed roar? Doherty plays with our expectations as he reveals traces of activity amongst the trees: a sleeping bag, a smouldering campfire, pieces of wire and plastic. Is this innocent litter or forensic evidence? As with most of Doherty's work the setting is Northern Ireland, however the pine forest suggests other European post-conflict landscapes. In Doherty's forest the event is left unspoken. However, the soundtrack, the artist reveals, originates from a distorted recording of a civil rights march in 1970s Derry. This detail is not made explicit in the film, but grounds the work, making it a poetic comment on both specific events and the universal ugly legacy of war.

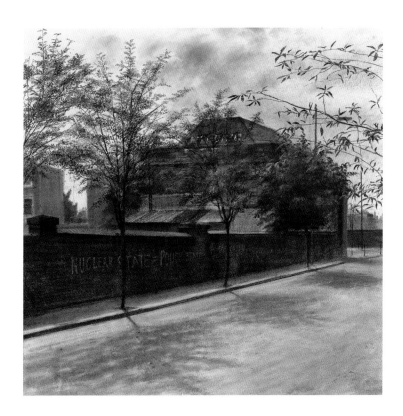

Eric Rimmington

Mildmay Grove looking to the South West
1985
Graphite, charcoal and conte crayon on paper,
602 x 604 mm

In 1983 Eric Rimmington began a series of ten drawings of an area near where he lived in North London. The series charts various points along the railway line between Canonbury and Kingsland Road. As he developed the series, Rimmington became aware of the fact that this was the route being used to transport nuclear waste between Sizewell nuclear power station and the Sellafield nuclear reprocessing plant in Cumbria. The precisely-executed graphite drawings have the overall feeling of a calm North London morning; there are only a few clues here and there to hint at the invisible, lethal toxins that may be passing nearby. The graffiti on the wall is the most explicit suggestion of the feelings of many at the time: 'Nuclear state = police state'.

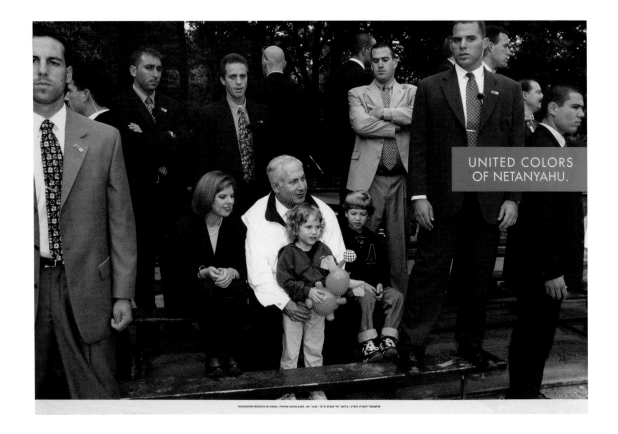

UNITED COLORS
OF NETANYAHU.

David Tartakover

United Colors of Netanyahu
1998
Lithograph on paper, 682 x 990 mm
Gift of the artist

David Tartakover is an Israeli artist, designer and political activist who uses the medium of the poster, often satirising or re-appropriating visual symbols to present a politically provocative perspective on Israel. Here he uses an image of the Israeli Prime Minister, Benjamin Netanyahu, posing for a press call with his family in a spoof of a United Colors of Benetton advert. With the smiling family surrounded by bodyguards, the artist implies that Israel militarises and fortifies its borders in order to maintain the illusion of Israeli society as a united, happy family. It is also a clear criticism of Netanyahu himself, who is often identified with an unwillingness to support the peace process between Israel and Palestine.

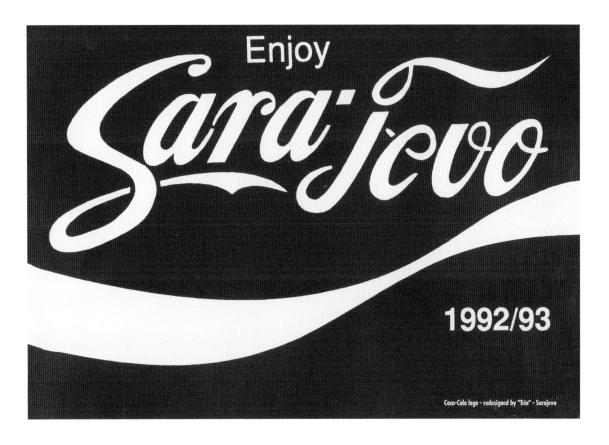

Coca-Cola logo - redesigned by "Trio" - Sarajevo

Trio Sarajevo

Enjoy Sara-jevo 1992/93
1992
Lithograph on paper, 458 x 657 mm

When war broke out in Bosnia in 1992, Trio Sarajevo, an award-winning design-led practice from Sarajevo, found themselves caught in the near four year siege and blockade of the city. The practice consisted of husband and wife Bojan and Dalida Hadžihalilović and their collaborator Lejla Hatt-Mulabegović. All were strongly influenced by the aesthetics and ethos of Pop Art and Punk. Isolated from the rest of the world, they produced a series of darkly humorous postcards, drawing attention to the plight of the city and satirising icons of art, advertising and film such as Coca-Cola, Absolut Vodka, the _Mona Lisa_, Marilyn Monroe and _Jurassic Park_. Throughout the siege the artists continued to work using limited resources. The postcard format was initially chosen for its portability and to suggest the idea of sending a message to the outside world, but later many designs were re-made as posters and reproduced by the international media.

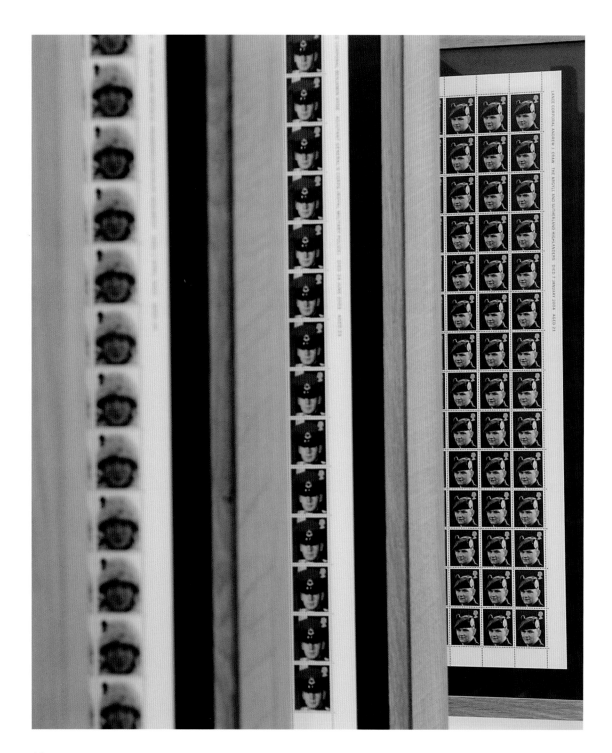

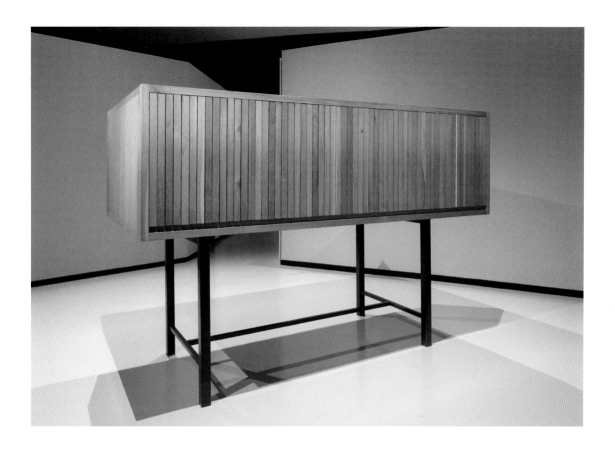

Steve McQueen

Queen and Country
2006

Mixed media installation, 1900 x 2600 x 1400 mm
Commissioned by the Trustees of the Imperial War Museum
Presented by the Art Fund

Queen and Country is a work that commemorates the individual British service personnel who died during the Iraq War, but also questions ideas of sacrifice, community and nationhood. The work takes the form of a large sarcophagus-like oak stamp cabinet, which viewers can open to reveal sheets of facsimile stamps each bearing a portrait of a service man or woman killed in Iraq. McQueen was commissioned by IWM in 2003 and visited Iraq shortly afterwards to research ideas for a work. Best known as a filmmaker, McQueen was frustrated by the limited opportunities to film in Basra due to the deteriorating security situation. He wanted to find an alternative means to respond to the conflict. He was particularly struck by the camaraderie of the troops, and sought a way to pay tribute to this. McQueen hoped that eventually the portraits, selected by the families of the deceased, would be issued as stamps and, as he states, 'enter the lifeblood of the country'.

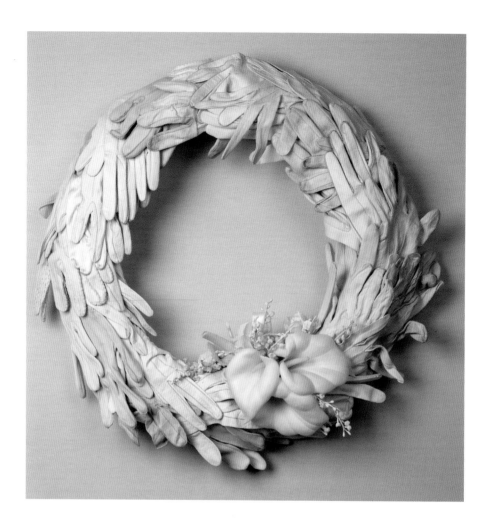

Rozanne Hawksley

Pale Armistice
1999
Mixed media, 510 mm (diameter)

Rozanne Hawksley's delicate work often comprises assemblages of fragments of lace, wood, embroidery and bones. It tells stories of mourning, grief, commemoration and loss. Sometimes her work refers to tragedies in her own life, or broader religious and literary narratives. *Pale Armistice* was created in memory of the artist's grandmother, who was widowed during the First World War and worked as a seamstress in Portsmouth, making naval uniforms. Through the traditionally 'feminine' medium of textiles, Hawksley articulates the hidden suffering of women bereaved during the First World War, commemorating not only the men who died, but also the struggles of the women who were left behind.

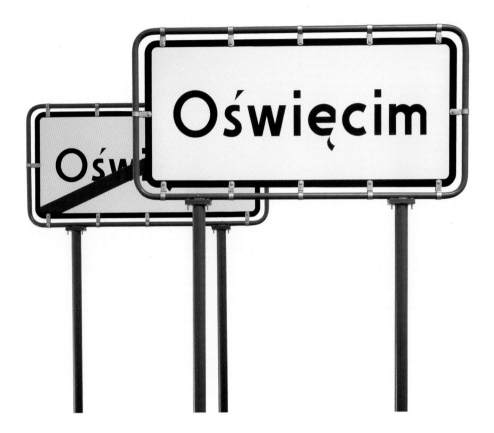

Darren Almond

Border
1999

Cast aluminium and paint,
2060 x 1320 x 610 mm (each)

During the period in which this work was produced, British artist Darren Almond made several works around the theme of Oświęcim, more commonly known as Auschwitz. Many of these projects involved re-contextualising mundane markers from the town, for example showing the town's bus stops in a Dusseldorf gallery. Here the entry and exit signs of Oświęcim are transplanted for the viewer to navigate. On the one hand everyday objects, they also mark the boundary of a place loaded with a dark history. Yet removed from that site, the signs become divorced from their context and significance. They raise questions about the links between memory and place and the resonances we attach to inanimate objects. The viewer can choose to move between the signs, to engage or not engage with their history.

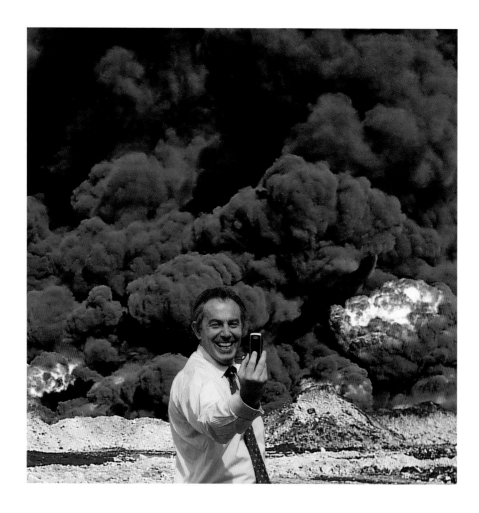

kennardphillipps

Photo-Op
2007
Pigment print on paper, 560 x 547 mm

kennardphillipps are Peter Kennard (whose solo work is shown elsewhere in this book) and Cat Phillipps, who have worked together since 2002, initially to make art in response to the invasion of Iraq. Their work is shown in a range of contexts: on the internet, in galleries, on billboards and protest marches. They describe their work as an integral part of political activism, a direct means of communication: 'the visual arm of protest'. *Photo Op*, depicting Tony Blair taking a selfie in front of a huge explosion, has become an iconic image, widely distributed online. The collage was produced in response to the anger the artists felt at the government's decision to go to war in Iraq in 2003, in the face of widespread public protest. kennardphillips describe their need to create an image that reflected and validated this public opposition to the war, sentiments they felt were not reflected in the mainstream media at the time.

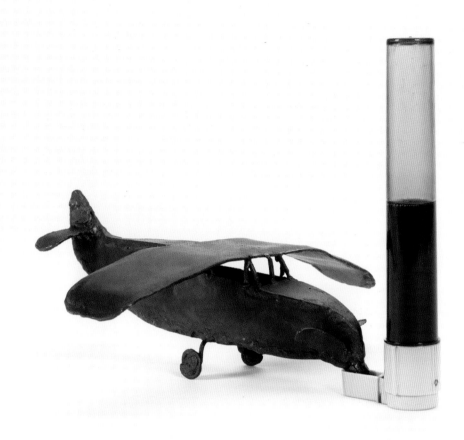

Phill Hopkins

Drinker, 1991
1991
Bird feeder, oil and metal, 171 x 290 x 224 mm

Yorkshire-based artist Phill Hopkins produced a number of works in response to the Gulf War in 1991. These were shown at an exhibition, *Flyers*, in Leeds Art Gallery in the same year. Many of the works featured small, fragile-looking planes, destroyed in various scenarios. Hopkins uses found objects in his sculptures, assemblages and installations which often have the feeling of a three-dimensional manifestation of a drawing or sketch. *Drinker* consists of a bird-like plane, greedily drinking oil from a ready-made bird feeder, implying the economic motivations behind the war: the need for oil from the Gulf.

Jananne Al-Ani

Untitled May 1991 (Gulf War Work)
1991
Silver gelatin prints, 160 x 160 mm (each)

Born in Iraq to an Arab father and an Irish mother, Jananne Al-Ani has lived in Britain since 1980. Perhaps as a result of her own complex identity, she has often investigated the construction of both personal and historical narratives in her work. In *Untitled May 1991 (Gulf War Work)* she explored her reaction to the Gulf War in 1991, watching events develop simultaneously from two perspectives; through the impersonal lens of the media, and as someone directly affected through her personal links to Iraq. The photographs are arranged in layers to show archaeological artefacts above family photographs, and formal portraits of her mother and sisters above media images of the conflict. These juxtapositions emphasise the complexity of events, often simplified by the media into polar opposites of 'them' and 'us', good and evil. They also hint at the destruction of Al-Ani's personal and cultural heritage.

The intimate references to the artist's family made in this work are also picked up in a second work by Al-Ani in IWM's collection. *A Loving Man* is an installation comprising five screens surrounding the viewer, showing the artist's mother and sisters. We see them play a memory game, each in turn recalling her absent father, who stayed in Iraq when the family moved to the UK. It is a work that references memory, myth and loss, highlighting the difficulties of exile.

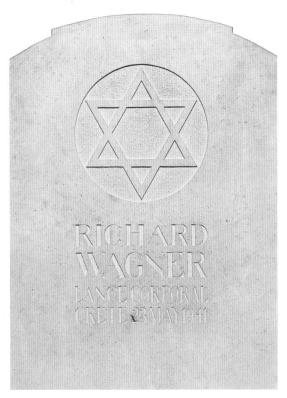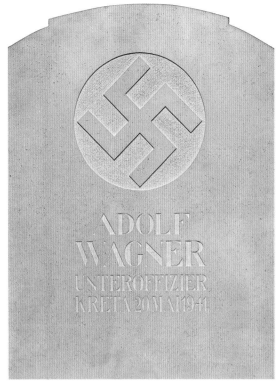

Tom Phillips

Einer an Jeder Seite/One on Either Side
1985–1988
Portland stone, 1120 x 572 x 100 mm (each)
Commissioned by the Trustees of the Imperial War Museum

In 1986 IWM approached Tom Phillips to make a work for the collection, settling on the retrospective theme of the Second World War and, more specifically, the military campaign in Crete. Phillips subsequently travelled to Crete and visited various historical sites. While exploring a German military cemetery he began to note the names of those commemorated and was struck by the very resonant collision of names on one grave: Adolf Wagner, referencing not only Adolf Hitler, but also the composer Richard Wagner. A few days later, in a British cemetery, a further poetic discovery revealed the grave of a Jewish soldier called Richard Wagner, who had been killed within days of the German Adolf Wagner. Struck by this poignant coincidence, the artist decided to make a double-sided gravestone, in a small attempt to heal the differences, prejudices and hatreds of war. The gravestone itself serves to remind us of the humanity of these two men, separated by their nationality and religion, but linked by their name, and made equal in death.

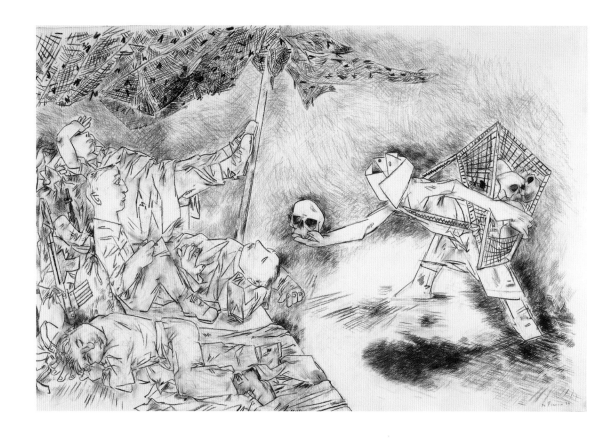

Peter de Francia

The Visitation
1989

Charcoal and pencil on paper, 722 x 1082 mm
Commissioned by the Trustees of the Imperial War Museum

Peter de Francia was best known for his painting *The Bombing of Sakiet,* an enormous painting of an atrocity during the Algerian War which is often compared to Picasso's *Guernica* or the work of Francisco Goya. However, in later years it was through large-scale charcoal drawings such as

The Visitation that de Francia seemed to find his richest form of expression. Often looking at social or political themes, his drawings have the narrative feeling of a myth or folk tale. He was commissioned by IWM in 1988 to produce a work on soldiers and mortality. De Francia had served in the British Army for four years during the Second World War and this drawing appears to present a fantastical scene suggestive of this period. We are shown a startled soldier being handed a skull from a basket by an anonymous figure. Is this a portent of the fate that is to befall him, or a consequence of his actions?

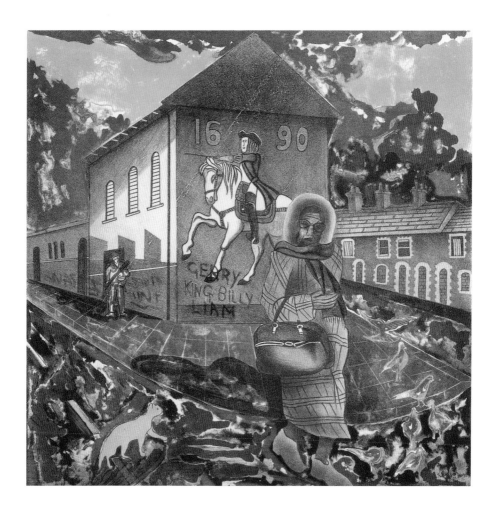

Anthony Davies

No Surrender No.35
1986
Lithograph on paper, 300 x 302 mm

This is one of fifty-three prints in IWM's collection by English artist Anthony Davies, who produced the work while he was living in Northern Ireland during the 1980s. His satirical and sometimes stark lithographs and lino prints depict keenly-observed characters on the streets of Belfast, often focussing on the symbols and signifiers of sectarianism. Davies' images of marches, clashes and violence suggest the rituals of a tribal conflict, divisions stemming from poverty almost as much as from religious difference.

Larissa Sansour

Nation Estate
2012
Single channel projection, 9 minutes
Presented by the Contemporary Art Society with additional
funding from Wolverhampton Art Gallery and IWM, 2014

This darkly humorous film offers a glimpse into
an imagined future in which a single high-rise
building contains a Palestinian 'homeland'. This
fantastical solution to the Israel/Palestine conflict
is a disturbingly dystopian vision, conceived shortly
after the Palestinian bid for nationhood at the UN
in 2011. We follow the artist as she returns home to

a building in which the inhabitants' neighbourhoods are digitally reconstructed and the water supply is sponsored by NGOs. Sansour employs sophisticated special effects and an electronic soundtrack to give the impression of a glossy sci-fi film; she has talked about the ability of sci-fi to distil and communicate the core anxieties, fears and hopes of a people.

The artist uses this in order to explore themes of land, territory, resource, freedom of movement and nationhood – all key issues within the conflict.

Rita Donagh

Shadow of the Six Counties
1981

Pencil, ink, crayon, watercolour and
gouache on card, 553 x 553 mm

Rita Donagh is best known for her layered and
thoughtful work on Northern Ireland and the
Troubles. As with many of her works, *Shadow
of the Six Counties* makes reference to maps,
cartography and diagrams, raising the spectre
of the consequences of actions, in this case the
imprisonment of paramilitary prisoners in the
Maze Prison. A delicately painted map of Ireland
is overlaid by the shadow of the six counties of
Ulster and the uncompromising outline of an
H Block, the infamous cell blocks in the Maze.
Donagh merges the figurative and the abstract,
resisting simplistic generalisations and leaving
the viewer with a powerful sense of ambiguity.
The juxtaposition is tense and ominous, the title
of the work emphasising this sense of foreboding.

Raymond Arnold

Penetration Zen/When Two Bullets Collide
1998
Etching on paper, 1372 x 692 mm

Blood and Bone/Haemorrhage Poem
1998
Etching on paper, 1372 x 682 mm

Double Camouflage/The Last Veteran
1998
Etching on paper, 1379 x 684 mm

Australian artist Raymond Arnold travelled to the Somme in 1998 following the path of his grandfather, a soldier in the First World War. Shown here are three of the resulting ten prints, a poetic response to the legacy of his family's experience. Arnold's unusual printmaking process creates shapes and patterns which make allusions to the frailty of the body, its protection and its destruction. The title of the print series, and an associated artist's book, is *Memory Becomes History*. This refers to the point at which society's lived experience of the First World War is lost, and the memory of events is retained only in archives, stories, history books and memorials. The images themselves all have two intentionally different titles, preventing one definitive reading. One half of the title refers to the historical war, while the other signifies the artist's psychological state: one implicated in the story of the other.

Al-Sammouni neighborhood,
Al-Zaytoun zone, south-east from the city of Gaza

Area: 200 m². Building on stilts (*mezallah*), open ground floor.
1st floor with 4 rooms, sitting room, kitchen, 2 bathrooms/wc. Quiet,
beautiful view of an orchard in the back. Inhabitants: 8 people

GH0809

GH0809

GH0809

Taysir Batniji

GH0809, Maison # 31
2010

Digital print on paper, perspex and metal,
357 x 271 mm (each)

Presented by the Art Fund and the Esmée Fairbairn Foundation
to IWM and Wolverhampton Art Gallery

Taysir Batniji is a Palestinian artist, born in Gaza, but currently living in exile in Paris. His work reflects on the situation in Palestine, but avoids the dramatic, drawing our attention instead to the irrationalities of the situation, to interrupted lives and restrictions on movement. *GH0809* is a satirical comment on the situation in Gaza, portraying houses bombed by the Israelis during Operation 'Cast Lead' in 2008–2009 through mock estate agents' information sheets. Batniji was not permitted to travel to Gaza himself so he asked a friend to take the images for this work on his behalf. The text on the documents presents desirable residences and includes mundane details such as square footage and the number of rooms. It also quietly states the number of former residents for each house. We are not told what has happened to these people, but the damaged and ruined structures shown in the photographs reveal the bleak reality.

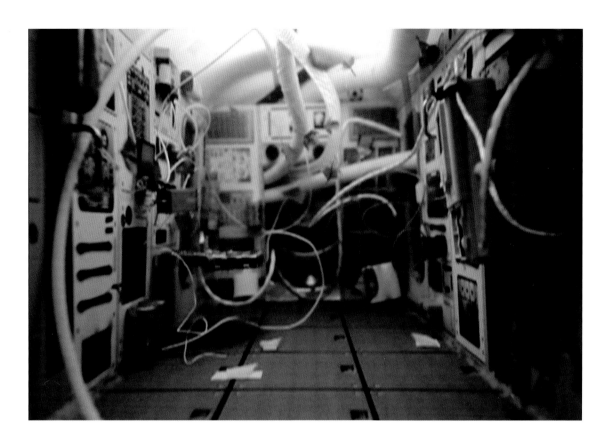

Kerry Tribe

The Last Soviet (still)
2010

Single channel projection, 10 minutes 44 seconds

Commissioned by Modern Art Oxford, Arnolfini, and Camden Arts Centre as part of the 3 series: 3 artists/3 places/3 years. Generously donated by the artist and commissioning organisations through the Contemporary Art Society, 2010

The Last Soviet tells the story of Sergei Krikalev, the eponymous 'last Soviet' of Tribe's film, a cosmonaut who was aboard the Mir space station for several months during the collapse of the Soviet Union in 1991. Using scenes filmed inside a model of Mir, Tribe re-stages the moment that Krikalev opened a parcel of autumn leaves, supposedly sent to him with a shipment of supplies. This is mixed with archival film, including the footage of *Swan Lake* that was played on Russian television to conceal news of the final days of the USSR. The voices of a male and female narrator are woven together, suggesting a documentary. However, the timing of these voice-overs and the images are mismatched. The viewer is unsettled, pushed into an attempt to match the visuals with the audio. Here, as in many of her other works, Tribe calls into question the reliability of memory and history. We become very aware of the way in which the story is told and constructed. The fluid borders between truth and fiction are laid bare.

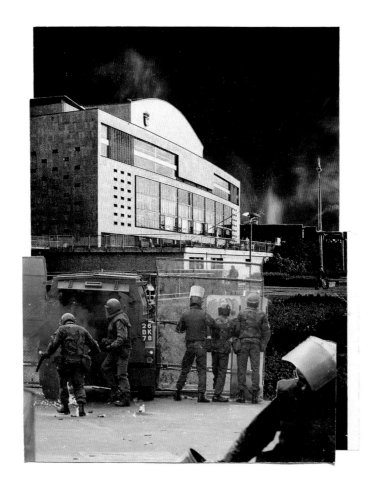

Sean Hillen

Four Ideas for a New Town #7
1987
Collage on paper, 454 x 404 mm

At first glance the photomontages for which Sean Hillen is known seem to suggest a clash of two worlds: soldiers in riot gear from a street scene in Northern Ireland are relocated outside London's Royal Festival Hall, an angry sky burning above. Hillen combines two places intrinsically linked through politics, history and violence. His work is a political commentary delivered with an often surreal and disturbing humour that disputes the possibility of representing the period in one image. Hillen grew up in the predominantly Catholic area of Newry, in Northern Ireland, surrounded by the fear and violence of the Troubles. When he moved to London to study he began this series of collages, often combining the idealism of tourist postcards with black and white images of street battles, riots, religious rituals and IRA funerals in Northern Ireland, images that he had taken as a teenager. The collages suggest the clash of experience embodied in Hillen's own biography, but also confront the viewer with the tension of living in a violent place.

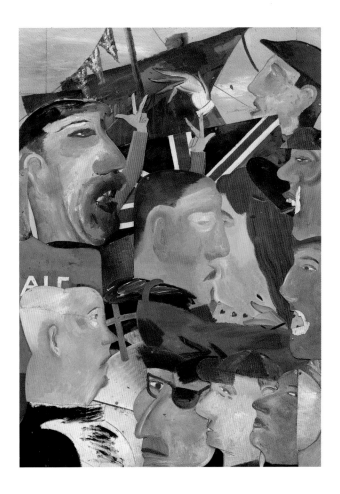

Jock McFadyen

With Singing Hearts and Throaty Roarings
1983
Oil and collage on card, 1780 x 1180 mm

The title of McFadyen's work *With Singing Hearts and Throaty Roarings* gives a feverish nationalist soundtrack with which to view his painting of the return of a battleship from the Falklands. The bow of the ship can be seen above the quayside throng, hung with bunting, but just below this is a coffin draped in the Union Jack, reminding us of the human cost of the war. Despite the fact that two 'victory Vs' can be seen above the crowd, their mood does not appear to reflect the enthusiasm of McFadyen's title. The painting evokes a sense of empty excess, critical of the surge in bombastic patriotism and the aggressively nationalist rhetoric surrounding the conflict. The couple embracing in the centre of the painting look blank and distant, while others look shocked, angry or confused.

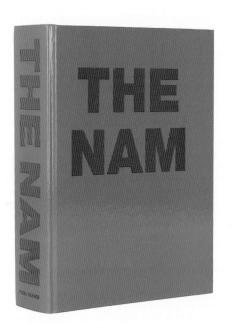

Fiona Banner

The Nam
1997
Artist's book, 287 x 215 x 67 mm

Banner's early work frequently looks at the uneasy relationship between visual and written narratives. This investigation has often taken the form of hand-written texts on gallery walls, 'wordscapes' in which she describes the action taking place in a film. Her artist's book *The Nam* takes a similar approach; here she describes six American films about the Vietnam war: *Full Metal Jacket, The Deer Hunter, Apocalypse Now, Born on the Fourth of July, Hamburger Hill* and *Platoon*. The hypnotic text presents a continuous present, a re-telling of narratives which are themselves fictions. Since publishing *The Nam* Banner has gone on to make a number of works about war and weaponry, most notably *Harrier and Jaguar* comprising two discreetly altered, decommissioned fighter planes, which raised questions about their violent but seductive power.

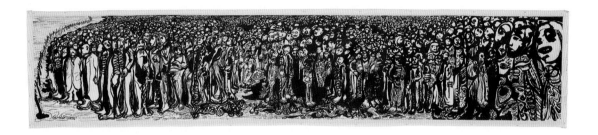

Osman Ahmed

Nugra Salman
2005
Ink on paper and linen, 650 x 3000 mm

Osman Ahmed's drawings stem from personal experience of the Anfal campaign, Saddam Hussein's attack on the Kurdish people in the late 1980s, in which it is estimated that almost 182,000 people died. The artist was born in Sulaymaniyah in South Kurdistan. He fled the assault, escaping to the Iranian Kurdish area, eventually arriving in the UK. In his work he uses a deceptively simple monochrome ink technique to portray massed crowds of people, exploring the shapes formed by crowds in both representational and semi-abstract images. Here individual faces emerge but are never divorced from the crowd, which appears to be a distinct entity, emphasising the scale of events, the chaos and trauma and the emotional weight of the memory.

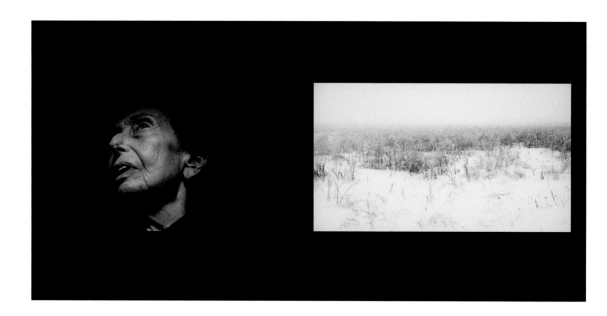

Ori Gersht

Will You Dance for Me (still)
2011
Dual channel HD video projection,
13 minutes 45 seconds

The voice at the beginning of this film belongs to Yehudit Arnon, who is shown rocking in and out of the shadows as we hear her story. While a prisoner in Auschwitz, aged 19, she was ordered to dance at an SS officer's Christmas party. When she refused, she was punished by being made to stand barefoot in the snow. Arnon pledged that if she survived she would devote her life to dance, later fulfilling her dream. Now, aged 85, she can no longer dance. As she rocks in and out of the light, a barren and disorientating snowscape appears, alluding to the site of her memories. The rhythmic rocking of her chair links past and present, memory and movement. The repetition resembles the indifferent nature of the passing of time. Gersht's film seems to suggest a last, beautiful dance. Towards the end of the piece Arnon begins to move, to dance, in a way that suggests that she is suffering, but at the same time that her defiance and spirit endure.

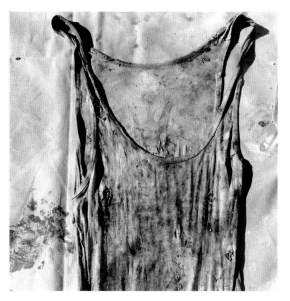 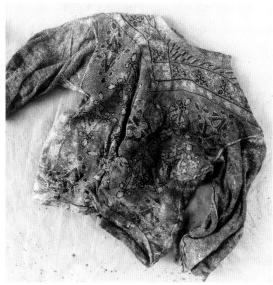

Frauke Eigen

from *Fundstücke Kosovo 2000*
2000
Silver gelatin prints, 499 x 500 mm

Frauke Eigen travelled to Kosovo in 2000, shortly after the end of the 16 month war there. Eigen heard that a mass grave containing the bodies of genocide victims was being uncovered near to where she was staying. Although she was in Kosovo working as a photojournalist, she felt the need to adopt a different approach to reflect the enormity of what she saw. Witnessing the recovery operation, she described watching bodies being dissected in the mortuary, recalling how she was overcome by the strong smell of formaldehyde. On leaving the site she was struck by the power of the personal possessions being removed from the grave, and the strong sense they gave of their owners' absence. She describes the objects she chose as being more 'human-like' than the corpses in the morgue. In this series of fourteen photographs she intentionally avoids graphic imagery and leaves it to the viewer to complete the violent story.

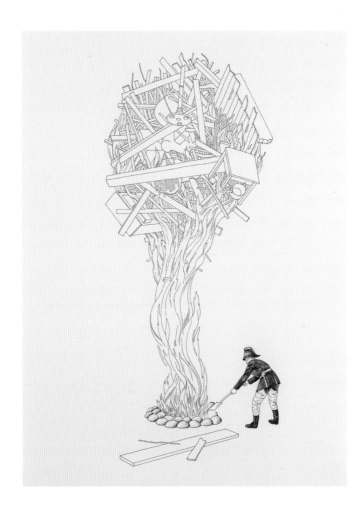

Mark Fairnington

Untitled (First Aid to the Injured)
1998
Ink on paper, 765 x 561 mm

Mark Fairnington's curious drawings show figures trapped and bound in weird contraptions, masked, suspended and carried in strangely cyclical configurations, revealing the human body as vulnerable and weak. Here we see a fireman ensnared in a cloud of smoke, wood, furniture, fencing and household goods. Fairnington's drawings capture a sense of the surreal in war, and are based on instructional diagrams from first aid and civil defence manuals, found in the archives of IWM. It is the very attempt to give clear instruction in these books that results in their strangeness. Fairnington has captured this through redrawing; he augments the uncanny, uncomfortable nature of the images and reveals the archives in a new light entirely.

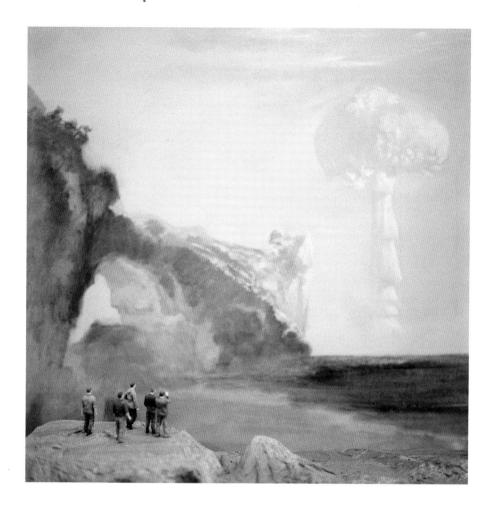

John Timberlake

Another Country XV
2001
C type print, 1000 x 1000 mm

The works in Timberlake's series *Another Country* began with a painted landscape, usually combining well-known Romantic paintings (in this case J M W Turner's *Rocky Bay with Figures*) with the addition of a nuclear mushroom cloud, drawn from photographs of atomic weapons tests held in IWM's archives. Timberlake then constructed a *papier mache* foreground with model spectators, and photographed the resulting diorama. The photograph is the only evidence of the endeavour, the model destroyed and recycled. Through the image the artist explores ideas about landscape and the modern day 'sublime', a term used to describe entities which are both terrifying and awe-inspiring. The atomic cloud is toxic and fascinating; however unlike the natural phenomena usually associated with the sublime, it is also a man-made construction. The multiple layers in the work remove us from the event, leaving us as passive spectators, simultaneously seduced and disturbed.

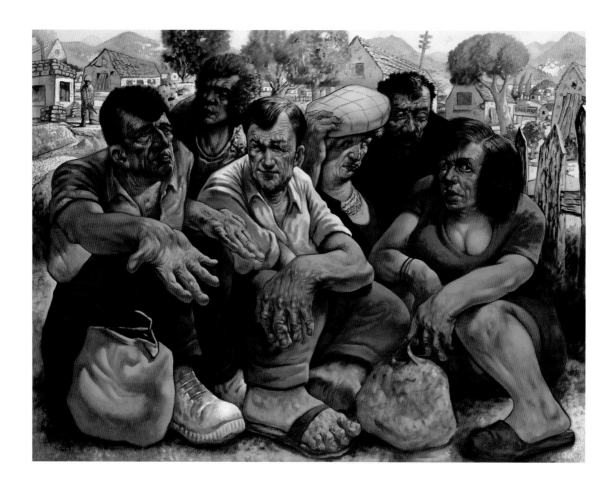

Peter Howson

Cleansed
1984
Oil on canvas, 1828 x 2463 mm
Commissioned by the Trustees of the Imperial War Museum

Peter Howson went to Bosnia as an Official War Artist to record the work of the UN peacekeeping forces. During the conflict he travelled to Bosnia twice, and initially struggled to create images that he felt adequately reflected the particular horror of that war. In one incident Howson came across this group of Muslim refugees on a roadside.

They had been driven at gunpoint from their homes by Croatians and had sought refuge in a UN camp, but were refused entry and told to travel with a convoy of tanks to a safe district. Howson shows them waiting at the side of the road, vulnerable, hungry and desperate, clutching their belongings in plastic bags. Without knowing their story the group could appear mundane, however the monumental and almost grotesque way in which Howson depicts them is reminiscent of the crowds in early medieval religious paintings. This gravity suggests a wider significance, however here there is no hope or solace.

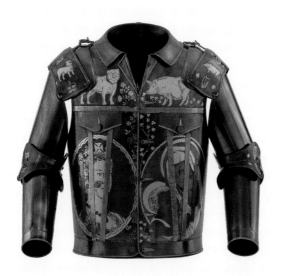 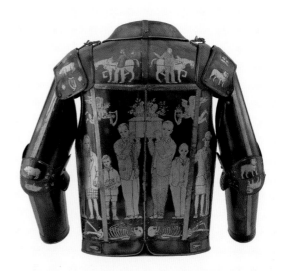

John Kindness

Sectarian Armour
1994
Etched steel and brass, 600 x 500 x 260 mm

Kindness's work from this period often explores the imagery of the Troubles in Northern Ireland. *Sectarian Armour* combines a denim jacket – in the Belfast-born artist's words, 'the uniform of the Belfast hard man' – with a traditional coat of armour. The object's historical appearance gives it a sense of authority which the artist uses to subvert symbols of Northern Irish sectarianism and highlight the absurdities of division. One side of the suit is adorned with British Loyalist imagery, the Queen and the bulldog. On the other side is Irish Republican iconography, the Virgin Mary, and an Ulster hog. Across the shoulders is a pastiche of the Levis Jeans logo, showing Gerry Adams and the Reverend Iain Paisley pulling in two opposite directions. The back of the suit shows a funeral – although the mourners are separated, they are united through their grief. This unifying factor is further emphasised by the grisly *memento mori* under their feet: two skeletons clutching handguns.

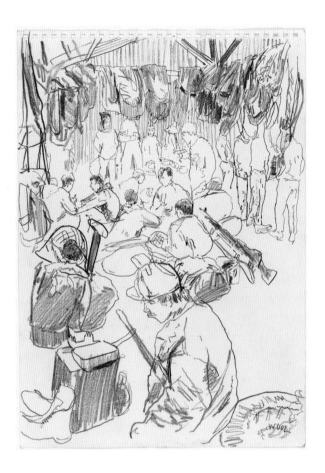

Linda Kitson

2nd Battalion Scots Guards in the Sheep Sheds at Fitzroy, 17 June 1982
1982

Conte crayon and ink on paper, 355 x 253 mm
Commissioned by the Trustees of the Imperial War Museum

Commissioned by IWM during the Falklands War in 1982, Linda Kitson was the first official female war artist to accompany the military into action. She travelled on civilian ships requisitioned by the Royal Navy, as women were not permitted on naval vessels at the time. The original intention was for Kitson to disembark at Ascension Island, but instead she stayed with the forces throughout the war. *Sheep Sheds at Fitzroy* is typical of the 400 works Kitson produced during the commission. She was generally a few days behind the action, as a result many of her drawings show the consequences and aftermath of events. Here we are shown cold and exhausted British soldiers sheltering among fleeces following the Battle of Tumbledown. Some critics remarked that Kitson avoided the graphic and gory reality of war. The artist herself agrees, claiming that it was out of loyalty to the men she was accompanying. However her loose style of drawing conveys an immediacy and intimacy with which she distances herself from press sensationalism.

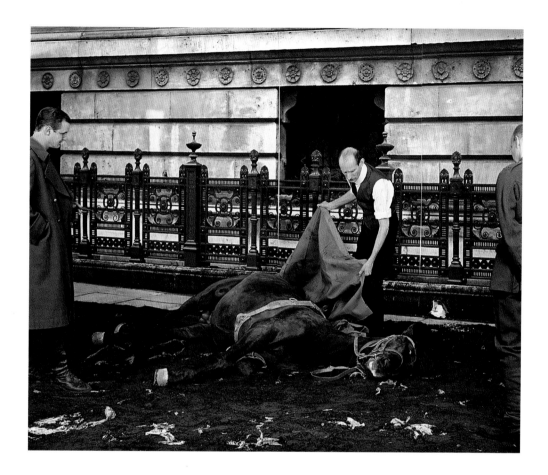

Paul Hodgeson

Slippage
2006
Pigment print on paper, 1480 x 1780 mm

Hodgeson's photograph is from a body of work commissioned by IWM to commemorate the 90th anniversary of the Battle of the Somme in 2006. Much of the artist's earlier work questioned historical narratives through the photographic re-staging of historical art works. This photograph is based on William Nicholson's 1917 painting for the Canadian government, *The Canadian Headquarters Staff*. Here, as in the painting, the home front and the battlefield are merged in the same space. Army officers gather around a dead horse, fallen on the soil of the Somme; the setting is the facade of the Foreign Office in London, revealed to be a stage set by the dislodged photographic panels. The relatively minor incident of the death of a horse, set against the magnitude of the First World War, is a means through which the artist raises questions about the forces of modernity and mechanisation that had transformed warfare during this period. He questions the ability of individuals and institutions to respond adequately, the detached response of the officers in the scene revealing their powerlessness in the wider situation.

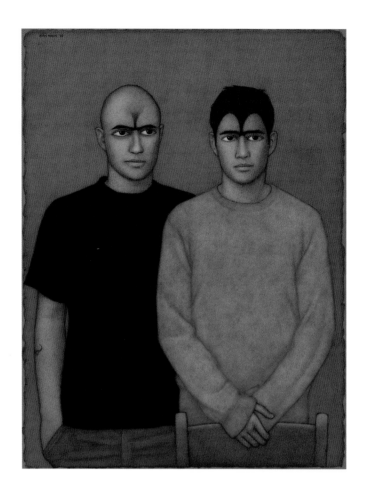

Shanti Panchal

Boys Return From Helmand
2010
Watercolour on paper, 776 x 592 mm

This is an intimate portrait of the sons of Indian-born, London-based artist Shanti Panchal. The work is a personal tribute to his sons, who both completed tours of duty with the British Army in Afghanistan, but the watercolour also addresses wider issues of British identity within contemporary conflict. Panchal's watercolours combine Indian and Western painting styles, capturing the complexities of a life lived between two cultures. This is echoed in the elder son's regimental tattoo, contrasting with the distinctive rendering of the boys' brows – a visual nod to Hindu god Shiva's third eye. This blend of references within the portrait alludes to the complex make-up and varied perspectives of the British armed forces.

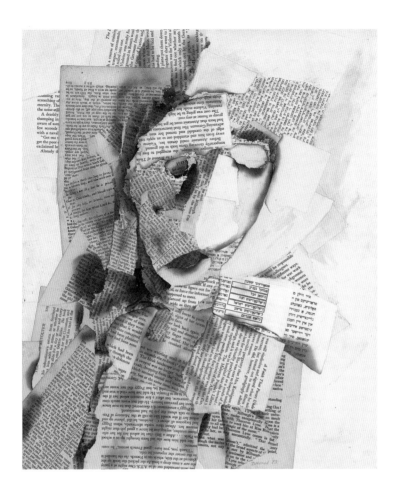

Shmuel Dresner

Benjamin
1982
Burnt newspapers and acrylic paint on paper,
445 x 375 mm
Gift of Shmuel Dresner

This is a portrait and tribute to the artist's close friend Benjamin, whom he met when they were both held in a concentration camp during the Second World War. The artist describes how, despite being a prisoner for two years, Benjamin maintained an elegant image, 'stylish and tough'.

He was always cheerful and optimistic and had helped Dresner cope with the death of his father in 1943. One day Benjamin and Dresner were called forward to volunteer for deportation. Benjamin was eager to step up as he hoped that those called earlier would be transported by train. Without knowing why, Dresner hid himself. He later learnt that those who had travelled by train, including Benjamin, were shot in a clearing. Dresner intentionally avoids graphic representation of the trauma and sadness of their circumstances, while making reference to destruction and violence through the torn and burnt papers from which he constructs the image.

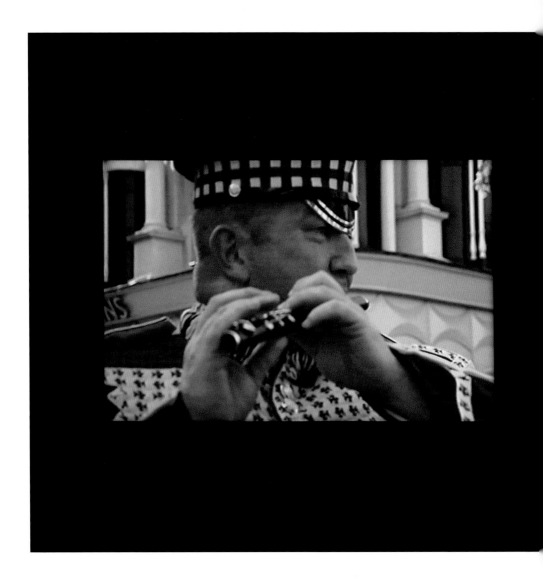

Roderick Buchanan

Scots-Irish/Irish-Scots (still)
2011
Dual screen projection, 70 minutes
Commissioned by the Trustees of the Imperial War Museum

Roderick Buchanan's film installation – the result of a 2008 commission for IWM – considers the legacy of the Troubles in Northern Ireland following the Good Friday Agreement through the stories of two Scottish flute bands. The work grew from Buchanan's own personal interest in the two communities, coming from a mixed Catholic and Protestant family himself. Both Republicans and Unionists from Northern Ireland have always sought

and found support in Scotland. During the Troubles bandsmen from Northern Ireland would travel to Scotland regularly in support of Scotland's major parades; Scottish people in return would do the same for the big parades in Northern Ireland. *Scots-Irish/Irish-Scots* consists of two films displayed simultaneously in a pendulum edit, giving one side sound while the other is silent. The films are separated by a partition, the viewer allowed to choose their view. One film follows Black Skull Corps of Fife and Drum around the walls of Londonderry on the 320th anniversary of lifting the siege. The second film follows Parkhead Republican Flute Band during the annual Easter Rising Parade in Derry, 2010. The work takes a balanced viewpoint, highlighting the rituals and mythologies that each band continues to hold dear.

Paul Ryan

Concentrate
2001
Ink on paper, 830 x 1090 mm

Paul Ryan's artistic practice is heavily centred around the sketchbook, often as a vessel for recording memory. *Concentrate* is a work that stems from such a sketchbook. It is a work that could easily be overlooked, a deceptively simple note of a group of low-lying buildings. Yet this drawing evolved from a small pencil sketch produced while the artist was visiting a former concentration camp in Poland. Following his visit Ryan re-drew the picture in a larger format, the resulting work over a metre wide. Each stroke of the pencil and indentation in the paper is enlarged and carefully re-created in ink. The lines are transformed in an attempt to respond to the scale of the events that took place at the site depicted. This emphasis on scale suggests the impossibility of attempting to comprehend the Holocaust by visiting the remains of the camp, or viewing Ryan's own quick sketch. Through the title the artist asks the viewer to examine not only the way in which the drawing is made, but also to confront the enormity of events.

Miroslaw Balka

A Crossroads in A. (North, West, South, East)
2006
Lithograph on paper, 563 x 766 mm (each)

Polish artist Miroslaw Balka is best known for stark installations dealing with Polish history, often referencing Auschwitz and Treblinka concentration camps. This portfolio of four prints reflects on the Holocaust and on the nature of memory, recollection and history. The prints are titled *North, South, East* and *West*, referring to the direction of the roads depicted. Each image shows a corner of a crossroads in Auschwitz. All identifying features of the location or human presence are obliterated by the artist, leaving blank, empty spaces. By removing these traces Balka questions whether it is possible to remember or memorialise the full horror of the Holocaust. Simultaneously the terrible presence of what is missing hangs heavily over the viewer.

1. IWM ART 16363 © Sean Hillen
6. IWM ART 15091 © Colin Self.
 All rights reserved, DACS 2014
7. IWM ART LD 7548 © Whitford Fine Art,
 London
8. IWM ART 15587 © Edith Hofmann (Birkin)
10. IWM ART 17460, IWM ART 17460
 © Langlands & Bell
11. IWM ART 17180 1 © Langlands & Bell
†12. IWM ART 17635
 © Hughie O'Donoghue RA
13. IWM ART 16832 © Victor Sloan
14. IWM ART 15493 © Bill Woodrow.
 All Rights Resserved, DACS 2014
15. IWM ART 17553 © Annabel Dover
*16. IWM ART 17643 © The artist, courtesy
 Anthony Reynolds Gallery, London
17. IWM ART 17631 © Mark Neville
18. IWM PST 8854, IWM ART 15819
 © Peter Kennard
19. IWM ART 16020 5 © Peter Kennard
20. IWM ART 16725 © Chris Harrison
21. IWM ART 16803 2 © The artist
22. IWM ART 15654 1 and 2 © Michael Peel
23. IWM ART 16749 © Colin Self.
 All rights reserved, DACS 2014
24. IWM ART 15375 © Gilbert and George
 and White Cube
*26. IWM ART 17579 3 © The artist
27. IWM ART 16634 © Rasheed Araeen
28. IWM ART 17573, IWM ART 17575
 © Albert Adams Estate eTrust London
29. IWM ART 16414
30. IWM ART 16818 3 © Ori Gersht
31. IWM ART 16793 © The artist
*32. IWM ART 17638 © Yazan Khalili

33. IWM ART 16591, Image courtesy the artist
 and Matt's gallery, London; Alexander
 and Bonin, New York; Kerlin Gallery,
 Dublin; Galerie Peter Kilchmann, Zurich
 and Galeria Moises Perez de Albeniz,
 Madrid.
34. IWM ART 16024 © Michael Sandle RA
35. IWM ART 16824 © The artist
36. IWM ART 16746, Courtesy of Graham
 Fagen and Matt's Gallery, London
38. IWM ART 16660 © The artist
39. IWM ART 17514 © DACS 2014
40. IWM ART 17620 © Alison Wilding 2014,
 courtesy Karsten Schubert, London
41. IWM ART 16395 © The artist
*42. IWM ART 17559, Image courtesy the artist
 and Matt's gallery, London; Alexander
 and Bonin, New York; Kerlin Gallery,
 Dublin; Galerie Peter Kilchmann, Zurich
 and Galeria Moises Perez de Albeniz,
 Madrid
43. IWM ART 16802 7 © Eric Rimmington
44. IWM PST 8914 © David Tartakover
45. IWM PST 8596 © The artist
*46. IWM ART 17290, Courtesy the artist and
 Thomas Dane Gallery, London
48. IWM ART 16410 © Rozanne Hawksley
49. IWM ART 16762 © Darren Almond
50. IWM ART 17541 © kennardphillipps
51. IWM ART 16430 © Phill Hopkins
52. IWM ART 16417 © Jananne Al-Ani
53. IWM ART 16337
54. IWM ART 16371
55. IWM ART 16384 35 © The artist
†56. IWM ART 17633 © Larissa Sansour
58. IWM ART 15526 © The artist

59. IWM ART 16743 8, IWM ART 16743 10,
 IWM ART 16743 9 © R. Arnold
*60. IWM ART 17587 1-3 © Taysir Batniji
†61. IWM ART 17578 Courtesy Kerry Tribe
 and 1301PE Gallery
62. IWM ART 16363 © Sean Hillen
63. IWM ART 16248 © Jock McFadyen
64. IWM ART 16638, Courtesy the Artist &
 Frith Street Gallery, London
65. IWM ART 17648 © The artist
66. IWM ART 17615 © Ori Gersht
67. IWM ART 16804 © Frauke Eigen
68. IWM ART 17166 © Mark Fairnington
69. IWM ART 17027 © John Timberlake
70. IWM ART 16521
71. IWM ART 16636 © John Kindness
72. IWM ART 15530 52
73. IWM ART 17449 © Paul Hodegson,
 Courtesy Marlborough Fine Art
74. IWM ART 17596 © Shanti Panchal
75. IWM ART 17632 © The artist
76. IWM ART 17576 © Roderick Buchanan
78. IWM ART 16767 © Paul Ryan
79. Art.IWM ART 17591,2,3,4 © The artist

Captions by:
Sara Bevan

* Supported by:

† Supported by:

ArtFund♥

contemporary
art society